For Les Lurey,

 Without whose many courtesies, this book would have been impossible.

Morris G. Moses
Oct. 13. 1990

SPYCAMERA-
THE **MINOX** STORY

Walter Zapp taken in Tallinn, Estonia, 1937, by Nikolai (Nixi) Nylander. Natural light from window, ½ sec., Agfa 10/10 DIN film, with the Ur-Minox.
(Original photo, signed by Nylander, given to author by courtesy of Peeter Tooming, Estonian SSR)

MORRIS MOSES

HOVE
FOTO
BOOKS

Spycamera – The Minox Story

Morris G. Moses

First published in Great Britain August 1990 by
Hove Foto Books
34 Church Road
Hove, Sussex BN3 2GJ

British Library Cataloguing in Publication Data
Moses, Morris G.
 Spycamera : the Minox story.
 1. Cameras, history
 I. Title
 771.309

 ISBN 0-906447-43-7

Editors: Dennis Laney & Georgina Fuller
Design and Layout: Wendy Bann, Twyford, Berks.
Typesetting: Brighton Typesetting, Sussex
Printed by Cantz, Osfildern, West Germany

Spycamera – The Minox Story

Contents

Acknowledgments

The Minox camera was conceived by one person but required many others to make it a working reality. This book has been no different and throughout almost ten years of research the author has received the countless favors of others.

Representing the archival and library communities, Richard Boylan and John E. Taylor, National Archives of the United States; Constance Carter, Library of Congress; Alan Raney, Melina Yates, New York State Library.

The business sector has been very cooperative and their efforts are well represented by Donald O. Thayer Jn., Minox USA; Rolf Kasemeier, Erwin Pauwels and Klaus Rinn, Minox GmbH; Eleanor Quadri, VEF-Etablissements, Liechtenstein; Paul Klingenstein and Kurt Luhn*; Sam Schwartz*, Washington D.C.; Thomas D. Sharples; and Harry B. Henshel, Bulova Watch Company.

Minox collectors have played a vital part. Richard Conrad has undoubtedly made telephone company shareholders wealthy thru his near-infinite telephone calls to the author and has generously shared such Minox lore. Les Lurey has put much of his collection at the author's disposal and the members of the Japan Minox Club, including Hiroshi Kanai, Hajimu Miyabe and Masaharu Saitoh have all made kind gestures.

Personalities with Baltic background include Alfred Gerbers, Alberts Jekste* and Orestes Berlings — all of the Latvian-American community; Karlis Irbitis and members of the Latvian-Canadian Engineers' Society; and Dr.-Ing. Enn Hendre and Peeter Tooming, both of Tallinn, Estonian SSR.

The intelligence community has added valuable espionage-related material thru ex-FBI agent Kent Dixon, consultant, Crofton, Maryland; and Gerald B. Richards, special agent, FBI laboratories.

* deceased

George Gilbert, Eaton Lothrop, and Jack Naylor have all helped maintain the author's momentum over more than a decade.

Last, but vitally important, has been the personal correspondence with Walter Zapp. His ingenuity and endless determination was the primary inspiration for my researches.

Morris G. Moses
November 1988

In addition to the above, the Publishers would like to thank Peter Murton, Keeper of Aviation Records at the Royal Air Force Museum, London, for access to the negatives and papers of the late Lord Brabazon. Also to *The Sunday Times,* London, for additional assistance.

Dedicated to my wife Lucille.

Introduction

In the author's opinion, the Minox camera has as colorful a history as the legendary Leica. Although the Leica was used on occasion for espionage, it was never considered to be a spy's camera. Despite the controversy of whether or not the Minox was originally designed for espionage, the camera has had that image and the associated mystique, and it is the camera that most frequently comes to mind in connection with mid-20th century spying. The Minox is also unique in being the world's smallest high-precision camera, and the only subminiature camera system that has been in production for the better part of 50 years.

The camera is inseparable from its personalities. Walter Zapp, the primary inventor of the Minox, joins the select group of world-class camera designers. Born in Latvia, Zapp travelled all over Europe until finally settling in Switzerland. His dreams and struggles are chronicled here. Other personalities who played key roles in the success of the Minox were Ludwig Rinn and Donald Thayer Snr. Rinn came to the aid of Zapp after World War II and provided Zapp with a new start in post war Germany. Thayer's earlier foresight, as a buyer in the U.S. Army Post Exchange System in Germany in 1947, was to prove crucial to the success of Minox operations in the United States after the war and into the 1950's. Others, including Arthur Seibert, a leading optical designer, and Paul Klingenstein and Kurt Luhn, partners in Kling Photo, were to play vital roles in bringing the Minox to a wide circle of users.

Users included people from all walks of life, and the amount of documented lore surrounding the Minox is endless. The camera has been used to steal military secrets, as well as commercial secrets worth millions of dollars. The Minox has saved the lives of people trapped underground, and recorded the execution of a murderer. It has also been responsible for helping to bring a priceless art treasure to the Metropolitan Museum of Art in New York City.

Whether or not you have ever used the camera — whether you have ever been a spy, or might be one in the future — or if you are simply

Preface

Over fifty years have passed since Walter Zapp's brilliant design was first produced commercially in Latvia, at the VEF works in Riga. It might easily have been lost like so many other promising inventions of the time in the turmoil that was already beginning to engulf Europe. By a miracle, Zapp and his camera samples survived to come to rest eventually in Germany.

My family became involved when my grandfather decided to manufacture the little camera in the Rinn cigar factory in Giessen. It is still made there today, together with its "big" brother, the 35mm Minox.

I am very pleased to welcome Morris Moses' book as the Minox passes its half-century. Its ready adoption early in its life by intelligence and counter-espionage services, and by fiction writers of the genre, earned it the epithet Spycamera but that was not Zapp's intention. He saw it, like a good watch, as an elegant and delightful companion, recording the events of everyday life. I hope our customers stil regard it that way.

KLAUS RINN
Minox GmBH, Giessen

curious about the famous (and infamous) Minox camera — this tale of the tiny camera's birth and life through half a century should fascinate you.

Illustrations

Some of the photographs in this book are not of the quality we would wish but they are unique. In some cases they have been reproduced from snapshots where the negative was no longer available. They have been copied from prints, sometimes copies of copies. However, because of their great interest we did not want to omit them.

All photos supplied by author except where otherwise acknowledged.

CHAPTER 1

Walter Zapp and The Beginnings

Many of those who see or hear about the famous (and sometimes infamous) Minox spy camera for the first time look towards Germany, or sometimes even Japan, for its origin. The truth is that the honour belongs to neither country; the origins of the diminutive half-century-old wonder lie in the region of the Baltic — a geographic area relatively unknown to many people.

The Baltic countries — Estonia, Latvia and Lithuania — have experienced many political changes in the course of history. Situated south of Finland, west of Russia and east of Poland, these three tiny countries have gone through alternate periods of independence and subjugation many times. The 1905 revolution which attempted to wrest freedom from the Czarist regime, as well as from the Baltic Barons, was crushed by the Czar but the desire for Latvian independence became even stronger.

It was against this background that Walter Zapp was born in Riga, Latvia, on 4th September 1905. His father, Karl Zapp, was of German extraction and had been educated in England. Karl Zapp had travelled all over Europe as a manufacturer's representative in the late 19th century. During his travels he stopped in Riga where, through a friend, he was introduced to the family of Julius Burchard, owner of a large commercial operation. Through this connection, Karl Zapp met and later married Emilie Burchard. The marriage produced two sons, Edgar and Walter. After the outbreak of World War I, Karl Zapp was "classified of German Origin" by the Russians, which resulted in the banishment of the family to Ufa, in the Russian Urals. In 1918, Walter Zapp's mother returned with both sons to Riga, while Zapp's father, on his way to Sweden, was diverted to Reval (now Tallinn) Estonia. The family was reunited in 1921 in Riga upon the father's arrival from Estonia.

Walter Zapp's early schooling began in 1912 at the Albert-schule in Riga. This equivalent of an eighth grade education ended in 1920, amidst an adolescent life riddled with illness and emotional depression. Zapp, despite his lifelong inventiveness, never had the luxury of a full high

1

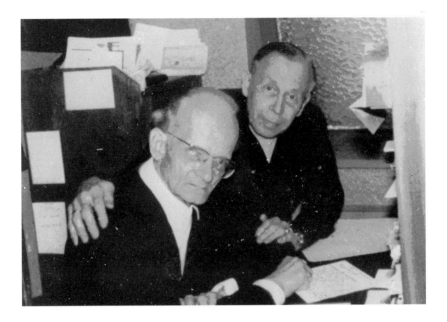

Walter Zapp and life-long friend Nixi Nylander taken in Switzerland 1972.
(Courtesy Nylander family)

school or college education. In 1922 , after two temporary apprentice-
ships, Walter Zapp went to work for Walter Lemberg, an art photo-
grapher in Reval. While at Lemberg's, Zapp met Waldemar Nylander, a
working photographer, and through Waldemar he also met the man who
was to be his lifelong friend, Waldemar's younger brother Nikolai. Nikolai
– nicknamed "Nixi" – was also an art photographer and from
discussions with him Walter Zapp conceived his first patentable
invention. On 24th November 1925 Zapp filed an application for that
patent, Estonian No.746. It was called "Paper cutting machine, especially
for photographs" and was a print cutter with adjustable guides to ensure
correct margins on the photographs.

Zapp's extreme curiosity and natural mechanical talents possessed him
early in his life with the fascinating potential of an extremely small
camera that would yield results equal to those from the medium formats
in the 1920's. The idea of such a small camera was not new, but it had
never been reduced to practical, high-quality hardware. This idea was to
haunt Zapp for the next ten years.

In 1925, Zapp was employed by Rambach, a photographic apparatus

dealer in Reval, and one of the first Baltic dealers to receive a small shipment of Leica cameras from Wetzlar. Zapp was intrigued by the Leica's design and construction. The job with Rambach ended in 1926, and for the next two years Zapp took odd jobs in advertising. In 1928 he went to work in the photo-finishing laboratories of Akel, where he helped develop a semi-automatic camera for copying rows of identification photos. At the end of 1929, after a bout of tuberculosis, he returned to photo-finishing, but he did not care much for it. During this period he sent some sketches and ideas for a small camera to Oskar Barnack, the designer of the Leica camera, at Leitz. Barnack never replied to the young, budding camera designer, and the world-wide economic depression of the early 1930's temporarily ended Zapp's dreams of any financial success in photographic ventures. Throughout this period, Nixi Nylander's friendship was the cornerstone of Zapp's emotional and physical survival.

At the request of Nixi Nylander, Richard Jurgens, a financier, visited Zapp at the Zapp family home, then on Waldeck Street in Nomme, a suburb of Reval. Jurgens ordered a custom-made enlarger to be built by Zapp, as one of Zapp's first trials in design. Jurgens' background was rather unusual. He had been born on 15th January 1900, in Reval, and had served as a lieutenant in the Russian-Estonian Army from 1917 to

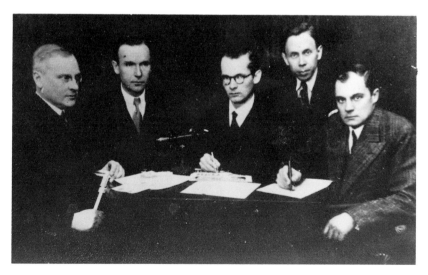

The early team circa 1937. Left to right: Hans Epner, Karl Indus, Walter Zapp, Nixi Nylander and Richard Jurgens.
(Courtesy Peeter Tooming and Enn Hendre)

1921. Prior to army service, he had attended the Revaler Realschule between 1910 and 1917. Somewhat of an entrepreneur, Jurgens became an independent merchant and industrialist in the years following World War I. As a result of these early meetings between Zapp and Jurgens, and at the insistence of Nixi Nylander, an informal arrangement arose in which Jurgens became the "money man". He would take 50% of any financial gains resulting from any of Zapp's experimental work. This partnership agreement dated from 16th August 1932, and was to continue until the years immediately following World War II. Jurgens was not too impressed with Zapp's early ideas on subminiature photographic systems, and continually pressed Zapp to pursue a line of design that would improve twin-lens reflex cameras to a quality superior to that of the Rolleiflex. Gradually, however, through Zapp's persuasion, and with continued intervention from Nixi Nylander, Jurgens became infected with thoughts of a commercially successful subminiature camera system.

Zapp's initial design ideas were so radical that he kept his thoughts mainly to himself. As an initial experiment he carved a block of wood to the dimensions of 13x28x75mm and rounded off the corners. It felt comfortable in the hand, perhaps one of the earliest attempts at what was later known in industrial design as "ergonomics". Starting with 35mm film dimensions, and a ratio of 1 to 4, Zapp arrived at 8.75mm which he took as his starting overall film width for the first Minox design.

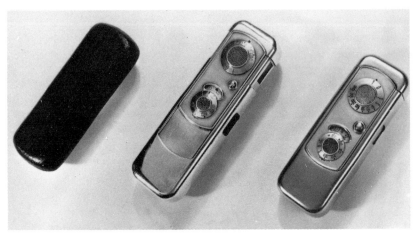

Left to right: Walter Zapp's original wood block; the Estonian Ur-Minox in the open, working position; and the Riga Minox prototype, closed.
(Courtesy Professor Enn Hendre, Estonian SSR)

The resulting format chosen was 6.5x9mm. From these primitive beginnings and a block of wood, the optical and mechanical design began to take form.

To those familiar with the so-called "Riga" Minox, these format dimensions may appear to be in error, but the historical facts are that the Riga Minox was the *second* Minox to be designed. The first, or "Ur-Minox", with the 6.5x9mm film format, would later be known as the Estonian prototype and this preceded the Riga. From the beginning the Minox concept involved two spool chambers, and Zapp had even contemplated as many as 100 exposures in one loading (shades of George Eastman). The long body design put the length of the cassette in parallel with the longest body dimension. The viewfinder was placed near the speed dial, and a film transport, roll-clutching mechanism was chosen. The three-element lens was recessed to avoid scratching of the front element and for lens shading. The telescoping cocking/winding design chosen was not entirely new, and had appeared in an earlier patent, U.S. No.521,563, granted to Alois Delug of Germany on 19th June 1894.

In late 1934, Zapp had finished his fundamental design and worked out the lens and shutter relationships. On 19th January 1935, the first set of plans were finished, and the problem of naming the camera yet-to-be came up. During the mid-1930's, many camera names ended in "ax" or "ox", not the least familiar of which were the *Contax* and *Ermanox*. Zapp drew up a list of what he considered to be short "harmonious sounding" names. Seeking out the help of his best friend, Zapp went to visit Nixi Nylander. Nylander read off the list of the names for the newly-conceived camera, but neither he nor Zapp were very enthusiastic. Finally, as Zapp was in the hall ready to leave, Nylander in a half-jesting manner called out "Minox". Both Zapp and Nylander agreed at that instant that this was a name that seemed to convey both a technical mystique and a resonant impact on the ear of a potential buyer. Shortly after the naming, Zapp drafted the basic early Minox logo which was essentially the five letters MINOX in a nearly straight line. This was considerably enhanced later by Adolfs Irbitis of VEF, who were to manufacture the camera, into the curved logo so familiar today.

On 16th August 1935, exactly three years after the signing of the agreement between Zapp and Jurgens, the last of several coloured transparent-overlay design drawings were dated by Zapp. These drawings became the basis for patents, and were shown to Hans Epner of Reval, a highly skilled precision mechanic. Production was originally planned for Tallinn in Estonia but there was a tremendous lack of skilled

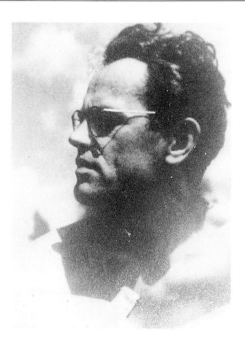

Adolfs Irbitis (1910-1983). VEF Minox graphics designer and industrial designer of VEF radio styles. Starting off as a young art student, Irbitis worked his way up to Advertising Director and was a winner of Grand Prix and Gold Medals in Brussels expositions of 1936 and 1958. His work was regarded as of the highest quality and artistic merit throughout Latvia for over 50 years.

manpower. Epner's services were in great demand by others, and the construction of the "Estonian Ur-Minox" prototype dragged on slowly. The problem of a good lens in such a small size camera posed one the greatest optical challenges of the time, and much to Epner's credit, Zapp was sent to Karl Indus, one of Tallinn's foremost opticians. After many glass lots had been sampled from Schott in Jena, and consultations had been carried out with Goerz Optical in Berlin, the lens took shape. The lens calculations were extremely time-consuming, highly empirical, and left much to be desired in the lack of freedom from many aberrations. The final design chosen was a three-element anastigmat. Schott's shipping records from the 1937-1942 period indicate that a total of 5500 pounds of optical glass was shipped to VEF in those five years, the majority of the glass being in slab form, and not as moulded lens elements.

By late Summer 1936, all the mechanical and optical parts of the Ur-

Minox were ready for final assembly. The conditions under which the parts were assembled would be both ridiculed and admired by the camera industry today. The lathe which Epner and Indus had to rely upon for final assembly of lens components had been occasionally used for truing automobile wheels! This left asymmetries in the lenses due to bearing wear in the lathe. In his memoirs and correspondence, Zapp says the Estonian Ur-Minox was silver-plated, with the implication that the body was brass, although Hendre (1989) says it was silver-coated stainless steel.

Up to the Fall of 1936, Jurgens, still Zapp's financial partner, had been repeatedly warned by many others to pull out of the venture. Jurgens chose to remain with Zapp, however. A feeler to Agfa at this time resulted in a complete lack of interest in Zapp's fledgling subminiature camera. After this rejection by Agfa, Jurgens sought out the Tallinn representative

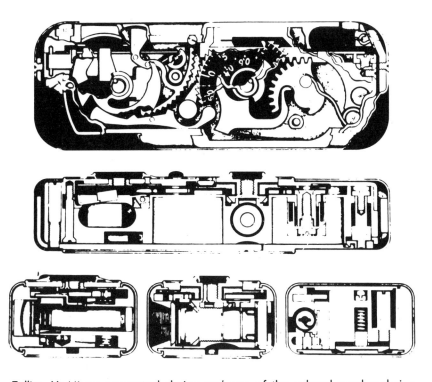

Tallinn Ur-Minox conceptual design and one of the colored overlay design drawings dated 16th August 1935 by Walter Zapp.
(Courtesy Enn Hendre and Peeter Tooming)

of VEF (Valsts Electrotechniska Fabrika). Although VEF was not a particularly photographically-oriented enterprise at that time, the Estonian VEF representative brought back the good news in August 1936 that an appointment had been made for Zapp and Jurgens at VEF headquarters in Riga, Latvia.

The VEF Era

On 7th September 1936, Zapp and Jurgens appeared at VEF, Riga, with the Ur-Minox prototype, a set of coloured design drawings, and sample photographs taken with the prototype and enlarged to 13x18cm. They were received by Teodors Vitols, the General Director of VEF. Vitols, the technical "soul and motor" of VEF, was born in 1888 in Taurkaln, Latvia, a small village 30 miles south-east of Riga. His higher education, begun in 1907 at the St. Petersburg (now Leningrad) Polytechnic Institute, was interrupted when it was discovered that he had participated in the 1905 Revolution. Vitols went to work for Siemens-Schuckert, a German firm in St. Petersburg, in 1909, and did not return to Latvia until 1920. After several jobs in the electro-technical trades in Latvia, Vitols joined VEF in 1932.

VEF was established in 1932 as an independent Lativan State Enterprise. The organisation developed out of the earlier Pasta-Telegrafa Galvenas (State Postal and Telegraph Complex). From the already-established telephone, cable, and mechanical departments, additional machine, light bulb, electromechanical, aircraft plywood, and optical departments were added. Starting with sales of 2 million lats (one lat equalled approximately 19 cents) in 1932, sales in 1939 were 15 million lats. Corresponding employment rose from 400 to 3400, which made for the employment of nearly 45% of all state independent enterprise workers at this one plant. By 1936, VEF radios were well known all over the world. The U.S. State Department received inquiries from National Radio of Malden, Massachusetts, concerning possible VEF counterfeiting of National communications receivers. An airplane designed by Karlis Irbitis, brother of VEF's industrial design chief, Adolfs, received first prize in a 1937 design competition in England. VEF also produced wind-driven electrical generators for farmers. The VEF aircraft plywood was world famous for its resistance to tropical climates. Ten per cent of VEF product output was exported. Employees' clubs, sports complexes, and a cultural centre that has become a show-place today, were all begun in VEF in the mid 1930's.

9

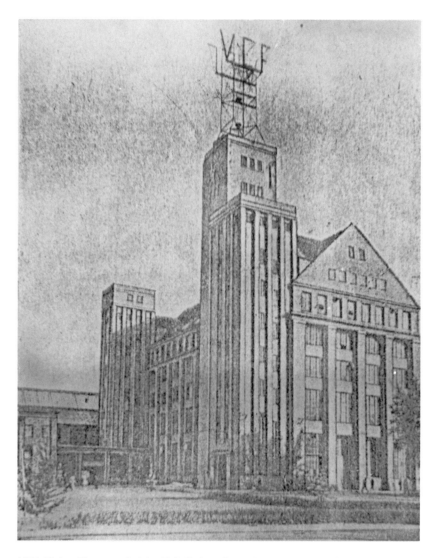

VEF (Valsts Electrotechniska Fabrika) in Riga, Latvia. Note radio antenna with letters VEF on top of building.

Vitols had been especially interested in optics and the graphic arts, and as a consequence was anxious to meet with Zapp and Jurgens. Their presentation to Vitols was based on the Estonian Ur-Minox prototype, which is still in Zapp's possession today. The silver-plated body and

complex of steel parts was their sole hope in demonstrating that they had a potential mass-production camera. When the 5x7in. enlargements from sample negatives were shown to Vitols, he was extremely sceptical, wondering if any retouching or "doctoring" of the negatives had occurred. Zapp assured him that, except for removal of dust spots and scratches, there were no tricks involved. Vitols requested that Zapp take new test photos in the presence of Vitols and other VEF witnesses. These extemporaneous test negatives and enlargements came back from the VEF laboratories within a few hours, and Vitols, in a burst of enthusiasm, extended his hand in congratulations over the remarkable results.

The initial contract between the Zapp-Jurgens partnership and VEF was drawn up and signed on 6th October 1936. An excerpt from the original contract reads as follows: "This contract concerns the miniature photographic camera and respective accessory apparatus discovered, invented, and built by Walter Zapp, called 'Minox', and hereby the camera is chief and beginning object and its technical description is in the contract. The camera and accessories will be referred to in this

Dr. Teodors Vitols (1888-1948) Director of VEF. His emigration to the United States was sponsored in 1946 by his nephew, Janis Vitols. In the States barely two years, Vitols died in New York City on 15th January 1948.

contract as the Minox apparatuses. The men, Walter Zapp and Richard Jurgens, confirm here in writing that the camera, according to the VEF at the signing of this contract, is the invention of Walter Zapp, and the property of both Walter Zapp and Richard Jurgens". The description embodied in the contract comprised three pages, and was basically the embryo of the present-day 9.5mm Minox with its larger 8x11mm picture format which was a result of the development of the production model.

The accessories mentioned in the contract were:

1. A clamp which enabled the camera to be fixed to any tripod or ball and socket head. This had provision for a cable release, which would also go naturally with a self-timer device.
2. A daylight-loading film developing tank.
3. An auto-focusing enlarger.
4. A negative-viewing device.

From the beginning, the Minox was well under way to becoming a "system" camera with this early list of accessories. After the signing, Walter Zapp recalls, they had a fish dinner in the VEF cafeteria in "the spirit of a new beginning". Ironically, on the heels of the signing of the contract, Zapp received a telegram from Agfa inviting him to an interview, but the path to VEF had already been travelled successfully.

Zapp moved from Nomme, Estonia, to Riga in November 1936. A man named Petters, partially responsible for some of the later shutter design, was the initial liaison man between Zapp and Vitols at VEF. The Riga Minox tooling began early in 1937 under Edvards Berzins. The effort involved over 65 individuals, including Indus from Estonia, Francis Fersts, and two Austrians named Blatnek and Mueller. Oakar Grinbergs, a designer, was assigned to Zapp, and Berzins, acting as production foreman, collaborated with Robert Erdmanis, a mechanical engineer and Latvian State University professor, to produce much of the tooling required for the Minox project. Other names in the VEF Minox enterprise included Zarins, Vientisis, Libis, and Schmit. Butulis, a technician, worked on many designs for the auto-focusing mechanisms of 20x30cm enlargers.

One prominent name was that of Alberts Jekste, Administrative Director under VEF's Vice-Director Juris Liepins. Albert Jekste was born on 21st June 1908 in Libau, Latvia, and had received his early technical schooling there. Upon graduation from Libau Middle School, Jekste went to work for VEF in 1931, and in 1932, passed entrance requirement tests for admission to the Latvian State University. He graduated as an electrical engineer in 1937. That same year, Jekste became interested in

the development of xenon high-intensity lamps for theatre projection, and also became very active in early audio-visual technology for teaching in schools. It was indirectly through Jekste's intercessions with the State president, Dr. Karlis Ulmanis, and also through Dr. Alfreds Bilmanis, Latvia's foreign minister to the United States, that the Minox project found early support.

Casting facilities were scarce in 1937, and the very technically-sophisticated, deep-drawn stainless steel camera body shells planned for the production models were a never-ending source of problems in die design and finish cleaning. The shells were partially developed by Darwin Steel in Sheffield, England with the help of VEF tool and die-makers in the Berzins group. The shutter assemblies required the soldering of brass and steel, and were often highly dependent for their quality on the skills of individual assemblers. The problem of compensating for the increasing film spool diameter on take-up had to be re-investigated by Zapp when he went from the Ur-Minox to Riga Minox design. The weakest point in

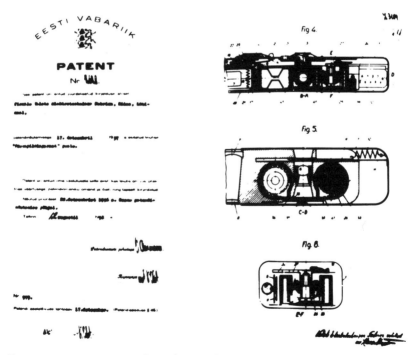

Estonian patent No.2628 of 22nd December 1936.
(Courtesy Enn Hendre and Peter Korsaks, Estonian SSR)

the design of the Ur-Minox had been the parallax compensation of the lens, and refinements were made and incorporated in a special patent for the viewfinder of the Riga. The viewfinder area of the Riga was enlarged and utilized more effectively than in the Ur-Minox.

A strong patent position had to be established for the Minox if it were to be sold successfully world-wide. On 21st December 1936 the first patent, No.7481, was registered in Finland under the title "An arrangement for the film transport with automatic compensation for increasing spool diameter". An Estonian patent, No.2628, was filed on 22nd December 1936. This was followed with patent No.7486 on 22nd December 1936, for "camera apparatus", and patent No.7492 "for daylight cassette for non-perforated film". On 24th December 1936, patent No.7498 was registered for "an arrangement for adjustment of lens" which was the helical focusing feature. Over the next few years more than 50 patent applications were filed and granted in twenty countries. It is interesting, and also a warning of how patent documentation can sometimes be confusing, that the patent for the camera itself was not the first to be filed anywhere in the world.

More tests with lens elements and the viewfinder involved Zapp's use of softened plastics, such as methacrylates ("Plexiglas" and "Perspex" were two commercial names for these) as test moulding materials, and quick substitutes for long periods of tedious lens grinding. Plastic lenses were not unheard of then, especially by Zapp.

Early on Zapp anticipated the 1958 Model B Minox with built-in meter by making experiments prior to WWII with photocells. But these were much too bulky to even think about putting into a camera the size of the Minox. The extinction-type exposure meter developed by Alois Leber in Austria in 1933 (later known as the "Leudi") gave Zapp some inspiration for a larger version using graphic symbols.

The bakelite postcard-size enlarger, using a transformer and low-voltage lamp, came next. Shortly afterwards Zapp conceived the idea for the film wallet configured to five rows of ten negatives each. The wallet has survived in the basic Minox system to the present day.

When the trademark was considered, there was concern on the part of Zeiss because of the similarity to their "Kinox" name which was used for certain motion picture items. An agreement was reached by which the Minox logo would be used in connection with the words "VEF-Riga".

In Spring 1938 commercial production began in earnest with an extremely slow yield of two cameras per day. According to Walter Zapp, the first Minox to be sold outside Riga was purchased by a French diplomat who later remarked on "its usefulness for office purposes". This

might be construed as a euphemism for espionage, a purpose which Zapp has steadfastly denied over the years as being the original design goal of the Minox. It is, nevertheless, one of the very few rigid-bodied cameras that will focus down to 8in. without the use of supplementary close-up lenses.

By mid-1939 the factory production line was turning out over 180 Minox cameras per month. Exporting to England had begun with the establishment of Minox Limited at 29 King William Street, later at 5 Victoria Street, London. The first advertisement appeared in *Miniature Camera Magazine* in September 1939, where the price was quoted as 17½ guineas (£18.7s.6d.). The camera was reviewed in the October issue and the author emphasised that it was not German, but came from a neutral country and should therefore remain available. The same issue carried an advertisement from Minox regretting a price increase of 10% brought about by War Emergency measures affecting shipping.

The United States looked like a most tempting financial prospect. Minox sales efforts in the U.S. can be traced back to a base established

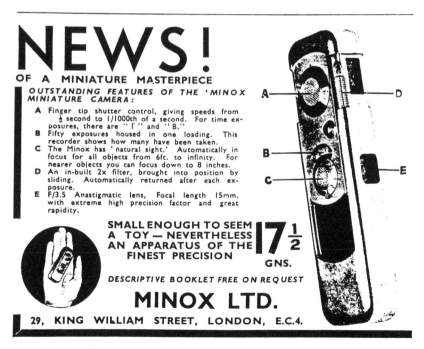

Advertisement, from September 1939 issue of Miniature Camera Magazine, by Minox Ltd., London.

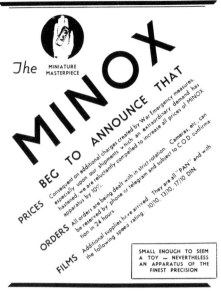

DESCRIPTIVE BOOKLET and FURTHER INFORMATION FROM:

MINOX LTD.

29, KING WILLIAM STREET, LONDON, E.C.4

'Phone: MANSION HOUSE 1120

Above: Minox Ltd. advertisement in the same magazine one month later, after the outbreak of war.

Below: Advertisement by Minox Inc., New York, circa 1940.

NOW AVAILABLE! *New and Revolutionary*

CAMERA

"The Miniature Masterpiece"

SPECIFICATIONS

Size—1¹⁵⁄₁₆"x1¹¹⁄₁₆"x3¼".
Weight—1¾ oz.
Lens — 3.5 highly corrected anastigmat (15 mm. focal length).
Shutter Speeds — ½-1/000 Time and Bulb.
Focusing—7¾" to Infinity.
Automatic parallax compensation.
Shutter winding and film transport automatic and simultaneous.
Built in 2X yellow light filter.
Daylight loading gives 50 exposures.

● Minox is a new Latvian camera slightly larger than a package of chewing gum, yet a most perfect piece of camera mechanism. Received enthusiastically in world markets, it is now available for the first time in America. Minox negatives (8mm by 11 mm) can be beautifully enlarged to the same proportions as 35mm negatives.

$79⁰⁰

Available through your dealer only.

MINOX, INC., 92 Liberty St., New York, N.Y.

File No.867.3
EAL/el

Consular Section,
Riga, Latvia, March 18, 1940.

Mr. Robert Henderson, Capt. USN Ret.,
Southern California Associated Newspapers.
829 Security Building
Fifth and Spring Sts.,
Los Angeles, California.

Sir:

Receipt is acknowledged of your letter of February
12, 1940, asking this office to inform you of the name of
the manufacturer and the cost of a miniature camera which
you understand is manufactured in Latvia.

The camera to which you refer is undoubtedly the
Minox camera which is manufactured by the State Electro-
technical Plant "VEF"., Riga, Latvia. While this camera
sells locally for 240 lats (about $45.00) it is not yet
exported and apparently there is no set export price.
A representative of this office has informed the "VEF"
people of your inquiry and they said that they would
write to you direct. A copy of your letter has been sent
to them and you should have a reply in the near future.

Very truly yours,

S. Allan Lightner, Jr.
American Vice Consul.

Reply from American Vice Consul, Riga, Latvia, in 1940 to inquiry about the
Minox camera from newspaperman in Los Angeles, California.
(Courtesy National Archives)

in 1935, when the New York firm of Ad-Auriema was incorporated.
Originally set up as an importer-exporter of electronic and motion
picture equipment, Auriema had been trading in the Baltic for many
years. In mid-1939, Janis Vitols, nephew of Teodors, arrived in the U.S.

to pave the way for VEF exports, including the newly-manufactured Minox. After successfully approaching Auriema for financial help, Janis Vitols, together with Auriema and John Mahoney, a New York attorney, incorporated Minox on 3rd June 1940, with offices at 116 Broad Street, New York City, which was Auriema's address at the time. Janis Vitols held 18 shares, Auriem held 1 share, and Mahoney 1 share, out of the total of 100 shares issued. The remaining shares were controlled by VEF-Riga. As a result of Janis Vitols activities with the Latvian-American Chamber of Commerce, and the Latvian-American War Relief Committee, the address changed in late 1940 to 92 Liberty Street where the Relief Committee had extra office space. Advertising in the American photographic consumer magazines had already begun in Spring 1940. Fotoshop and Willoughby's in New York City, and Bass in Chicago were running ads with the opening price advertised at $79. The Latvian local and export price was $45, as one enterprising Naval officer learned when he wrote to the American Consul in Riga.

CHAPTER 3

The World War II Years

The United States was unaware that there would be a Pearl Harbour when the Russians entered Riga for the first time on 17th June 1940. The Germans would temporarily take Riga over in the 1941-1943 period, for it then to be recaptured by the Russians in 1944. While the Russians and Germans were ostensibly alternate owners of VEF during parts of World War II, the manufacturing rights and legal title to Minox goods during that period, especially in the U.S., posed a much more complex situation. Jurgens and Zapp had consummated their deal with VEF prior to the war, including assignment of key patents to VEF. When the war engulfed the Baltic in 1940, Janis Vitols temporarily lost contact, as well as physical and legal control of the merchandise he was importing. Some Minox goods had found their way legally into England and Switzerland between 1938 and 1940, and Vitols was able to draw limited stock from these sources after June 1940.

On 1st April 1941, Dr. Alfreds Bilmanis, exiled Counsel General and Minister Envoy from Latvia, residing in the U.S., legally conveyed all VEF Latvian rights to U.S. patents No.2169548 (the camera), No.2161941 (film feed-transport) and No.2218966 (cassette) to Janis Vitols' firm in New York; Minox Inc. Title was not in Vitols' hands, but there was no force of assurance of delivery of merchandise. Earlier on 11th February 1941, an even more visionary agreement had been drawn up between Vitols and Bilmanis. The terms of this earlier agreement gave Vitols Latvian assets of $44,912.60. From this was deducted $10,392.66 (due to the Latvian Government) as a 33⅓% sales commission for underwriting publicity, advertising and promotion of the Minox in the U.S. A further deduction of $4,980 was made as a warranty set-aside of $5 each on 996 cameras. Another item was an allowance of $4 each for rebuilding 150 cameras, and still another allowance for $823.40 for "faulty merchandise". One more item was $3250 due to VEF A.G. in Zurich, Switzerland. Historically, the most significant aspect of this agreement was the inclusion of a $10,000 allowance to Vitols from the Free Latvian

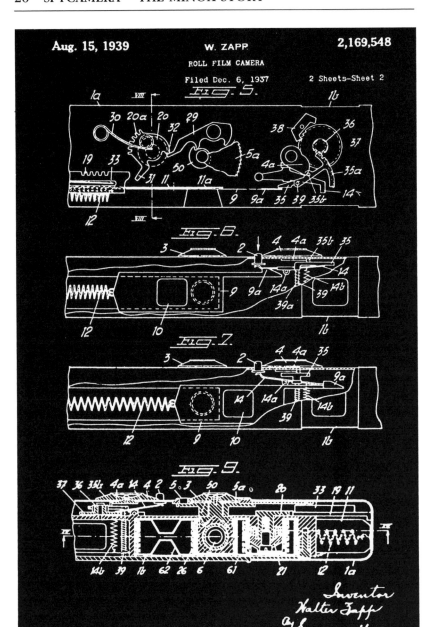

U.S. patent No.2169548, for roll film camera (Minox), filed 6th December 1937.

UNITED STATES PATENT OFFICE

2,339,615

LOCK

Charles Castelli, Union City, N. J., assignor
of one-half to Minox, Inc., New York, N. Y., a
corporation of New York

Application May 21, 1942, Serial No. 443,877

4 Claims. (Cl. 287—52.09)

The invention relates to locks or clamps for
adjustably securing a mounting bracket on a tube
or supporting rod, and for clamping telescoping
members such as a tubular member which is ad-

Fig. 8 is a side elevational view of a photo-
graphic enlarging apparatus, illustrating the ap-
plication of the locking device shown in the pre-
ceding views to supporting means for the lamp

Jan. 18, 1944. C. CASTELLI 2,339,615

LOCK

Filed May 21, 1942

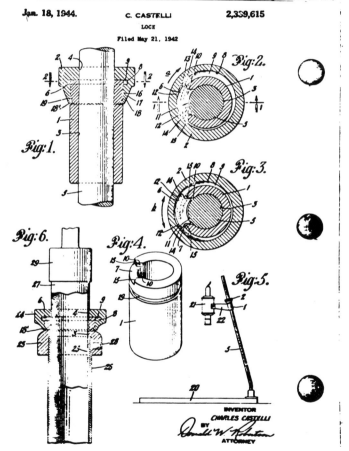

INVENTOR
CHARLES CASTELLI
BY
Donald W. Robinson
ATTORNEY

The Castelli patent No.2339615 filed in 1942 for an enlarger column lock.
Castelli, an independent inventor, assigned only a half interest to Minox Inc.,
possibly under part of the $10,000 research funds available in late 1941 for
development of U.S.-made Minox equipment.

Government "for their (Minox Inc.) undertaking to do research work, with reference to the *manufacture of Minox cameras*, films and accessories *in the United States of America*" (Author's italics). In a further optimistic vein, VEF also asked for a royalty of 5% of the net wholesale price on any such cameras manufactured in the United States. The major intent of the 11th February 1941 agreement was to assure continued production of the Minox in the United States during and after World War II. While it did not play any role in either helping or stopping U.S. manufacture, another Zapp patent, No.2278505, "viewfinder for photographic apparatus", was seized under order No.669 of the U.S. Alien Property Custodian's Office on 4th July.

No evidence has been found to date of expenditure of the $10,000 American manufacturing allowance, except possibly U.S. patent No.2339615 filed on May 18th 1942, by Charles Castelli of Union City, New Jersey, for a lock on the column of an enlarging apparatus. The patent assignment indicates only one-half interest was assigned to Minox Inc.

In Summer 1941, after the first brief occupation of Riga by the Russians from 1940, German troops entered Riga and control of VEF was taken over by AEG (Allgemeine Electrizitats Gesellschaft), an international electrical trust headquartered in Berlin. Twenty five percent of AEG stock was held by the international General Electric Company, and A.E.G. had representatives in over 40 countries on all five continents. The authority to control VEF was in the form of a *Vollmacht* (Power of Attorney) dated 21st January 1942. The *Vollmacht* recognized Otto Rusche, an A.E.G. director, as chief of AEG-VEF operations in Riga, Berlin and Switzerland. The Swiss Minox operation later grew into the present VEF Establishment of Vaduz, Leichtenstein after WWII.

Between 1941 and 1942, Zapp left Riga and travelled to the Agfa-Kamerawerke in Munich to see Dr. Lingg, a director of research and development. Renewed attempts to interest Agfa in the European production of the Minox failed. After this, in the interval from 1942 to 1943, Zapp travelled back to VEF in Riga to see the new works director there, a man named Berrets, in attempts to execute a new contract under the Germans. Sometime during 1942 or 1943 Zapp had met Rusche who saw the inventive potential of Zapp's intellect. Rusche promptly recommended Zapp for work at the AEG Research Institute in Berlin. The Minox was of minor commercial attraction to AEG's research and sales people at that time, and Zapp was assigned to work as chief designer under Dr. E. Bruche. This group was responsible for refining the pioneering work of Karl Ramsauer in 1933 on electron microscopes.

VALSTS ELEKTROTECHNISKA FABRIKA

RIGA, DORPATER LANDSTRASSE 19

Telegr.-Adresse: „VELFA · RIGA"
Codes: Rudolf Mosse
A.B.C. 5m Ed. Impr.
Telephon:

BANKEN:
Reichskreditkasse Riga Girokonto
Latvijas Banka Riga № 17000X
Postscheckkonto, Riga № 90028

Ihre Zeichen	Ihre Nachricht vom	Unsere Zeichen	Sachbearbeiter	Riga
		33/D		21.1.1942.

Betreff: V o l l m a c h t

Die VALSTS ELEKTROTECHNISKA FABRIKA, Riga, erteilt hiermit

Herrn Direktor Otto R u s c h e ,

Mitglied des Vorstandes der Aktiengesellschaft Allgemeine Elektrici-
taets-Gesellschaft, Berlin, wohnhaft Berlin-Zehlendorf-West, Goethe-
str.27, Vollmacht, die VALSTS ELEKTROTECHNISKA FABRIKA, Riga, in
allen Angelegenheiten zu vertreten, welche die VEF A.G., Zürich, be-
treffen. Die VALSTS ELEKTROTECHNISKA FABRIKA, Riga, besitzt die
Aktienmajoritaet der VEF A.G., Zürich.

 Herr Direktor Rusche ist zu allen Rechtshandlungen und tat-
saechlichen Handlungen befugt. Er soll berechtigt sein, die VALSTS
ELEKTROTECHNISKA FABRIKA, Riga, gerichtlich und aussergerichtlich und
vor allen Behoerden und Aemtern zu vertreten.

 Herr Direktor Rusche ist insbesondere befugt, im Interesse der
von ihm vertretenen VALSTS ELEKTROTECHNISKA FABRIKA, Riga, die Einbe-
rufung einer Generalversammlung der VEF A.G., Zürich, zu beantragen
und an dieser als vollstimmberechtigtes Mitglied teilzunehmen.

 Herr Direktor Rusche ist befugt, diese Vollmacht auf dritte
Personen oder Koerperschaften zu uebertragen.

VALSTS ELEKTROTECHNISKA FABRIKA

Copy of the Vollmacht (Power of Attorney) granted to Otto Rusche, AEG
Director, by VEF Riga during the German occupation of Riga in 1942. Notary
stamps are shown at top left.

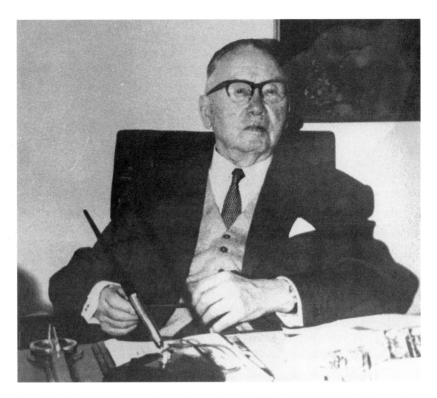

Otto Rusche (1883-1972). Board member of AEG and VEF's Swiss Connection during WWII. Photo circa 1956.

Zapp worked at the AEG Research Institute until September 1945. One of Zapp's publications from that period, *A Russian Galvanometer* (translated title) can be found in *Physikalische Blatter* 9, 1944.

Rusche's role in the history of the Minox was marginal, but important. After the first Russian occupation of Riga, elements of the Latvian government, under duress, quietly persuaded AEG that VEF be taken over under earlier agreements from WWI. A "daughter" company VEF-AG (not to be confused with AEG) in Switzerland had been founded by Teodors Vitols in 1939. Switzerland had frozen German assets after the outbreak of WWII but the German government had nevertheless decided to take over the assets of VEF-AG, then headquartered in Zurich. Otto Rusche became a member of the AEG board on January 1942, and because of his contacts, was chosen to reclaim the VEF/Zurich operations. VEF-AG was put under sequestration and administered by

two Swiss officers, one of whom was Walter Engel who became Otto Rusche's son-in-law. Attempts to expand Swiss patent rights after the war were complicated when Minox GmbH acquired these rights in the mid-1950s. The *Vollmacht* was the key to the AEG takeover of VEF during the German occupation, and was signed by G. von Gisovius, Chief of the OKW (High Command of the Armed Forces). There was also an additional *Bescheinigung* or back-up certification order issued by von Gisovius on 4th June 1943.

The second and final WWII Russian occupation of Riga took place in Spring 1944. In March 1944, according to a report of the Electric Equipment Division of the United States Strategic Bombing Survey, part of VEF was evacuated first to Torun (a city in northern Poland) and then to Koppelsdorf near Sonneberg in western Germany. This report listed the names, education, and VEF occupations of 92 people, some of whom are still alive today. Francis Fersts, one of the optical technicians involved with the design of the Riga Minostigmat lens, was listed as was Oakar Grinbergs, the designer assigned to Zapp at VEF. There was no mention of any Minox manufacturing activity. The Koppelsdorf operation appeared to be mainly electronics and radar, and was also referred to as AEG-Ostlandwerk, GmbH. The two Russian occupations have left their marks in the form of the "Russian Riga" cameras which are described in detail in Part Two of this book.

The Early Postwar Period

In mid-Summer 1945 Walter Zapp was lost amid the thousands of war-displaced persons and refugees in post-VE Day Germany. Remarkably, he had managed to hold on to his Estonian Ur-Minox and also one early prototype of the VEF-Riga Minox. These two cameras were to survive with him throughout the very difficult early post-war days and the military occupation of Germany. On a few occasions they were seized temporarily but miraculously promptly returned because the authorities did not know or care about the significance of what they were inspecting. Zapp's questionable status as a Baltic refugee who had not chosen early repatriation under Hitler's "Return Orders" caused much confusion to the members of the U.S. intelligence teams conducting interviews for the *Fragebogen* (questionnaire) which summarized an individual's life. During one of these interviews Zapp was asked to surrender the cameras. Shortly afterwards they were returned and he. was informed that the authorities had established his identity positively through his possession of both the Ur-Minox and Riga Minox prototypes. Someone with a good knowledge of developments in the photographic field "had a good line" on Zapp. Throughout all these interviews, Zapp insisted that the cameras were not solely his property, citing the legal agreements with Jurgens, and through these, the connection to VEF/AEG and VEF-AG in Switzerland.

Zapp was also interviewed by Lt. Thomas D. Sharples of the Optics and Fine Mechanics Division of OMGUS (Office of Military Government of the United States) in Fall 1945 near Bayreuth, Germany. Sharples' background as a graduate engineer and member of the well-known Sharples Manufacturing Corporation family, qualified him for a very competent technical interrogation of Zapp. In addition, Sharples had a strong interest in photography from pre-war days when he had written for several photographic journals. Sharples recalls Zapp's pale, delicate features as he spread all his possessions on a table, including the cameras. He was impressed not only with the ingenuity that was inherent in the

design of the cameras, but was also with Zapp's total sincerity and conviction about the future success of manufacturing the Minox commercially. He later managed to locate a very fine Lorch tool-maker's lathe, a Deckel milling machine and some drafting equipment, which were quietly "liberated" on a Sunday morning and presented to Zapp.

In the meantime, Jurgens had reappeared in the Wetzlar area, having kept in touch with Ernst Leitz during the war as an *Angesteller"* (one in the employ of the company). In September 1945, Zapp and Jurgens were reunited and incorporated, with the permission and encouragement of OMGUS, as "Minox-GmbH-Wetzlar". They set up their operations in an abandoned spinning mill on Bahnhofstrasse in Wetzlar. Edwards Berzins and a few others arrived from Riga to join in the beginnings of postwar Minox manufacture.

The Minox lens design had plagued Zapp from the very beginning. Even the best of the old 3-element Minostigmats lost much detail at the corners. Jurgens had learned of Arthur Seibert who had been employed by Leitz since 1920 as a lens designer. He arranged for Seibert to meet Zapp and the relationship grew into a full-time association when Seibert left Leitz in May 1947 to undertake lens design for the postwar Minox. The first of these designs was a 5-element lens named "Pentar" by Seibert. The rear element of this lens was called a "film-lens" because it actually came in contact with the film during exposure. The design employed curvilinear correction by actually clamping the film between

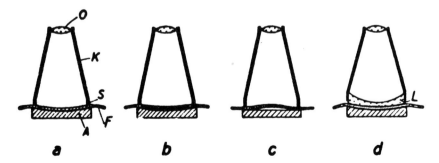

Abb. 509. Filmlage in der *Minox*; *O* Objektiv, *K* Kamera, *S* Bildfenster, *F* Film, *A* Andruckplatte, *L* Linse (Filmlinse)

Schematic drawings of the rear element of the 5-element Film Lens design, early Minox II era, 1949.
(from *Die Wissenschaftliche and Angewandte Photographie* by Kurt Michel — courtesy Springer-Verlag)

the rear lens element and the pressure plate, but it also created many dirt-trapping and scratching problems with the so-called "Minox II" from 1948 to 1950. Access ports, and cork or chamois swabs, which were furnished with some Model II's, failed to overcome the problems with this lens design, and both Zapp and Seibert were very discouraged at the minimal gains of the 5-element design over the pre-war Minostigmat. Seibert redesigned the lens as a 4-element recessed unit that incorporated both front mechanical protection and sun-shade, and most importantly, did not come in contact with the film. Seibert's idea of a curvilinear film plane in his designs was not a new one, having been used as early as 1913 by Herman Casler in U.S. Patent No.1082678 in which the film was kept in the curved shape of the film guide by vacuum. This second design with the 4-element non-contacting compensating plane was called "Complan", derived from the first three letters of the word "compensating" and first four letters of the word "plane". The Complan was used in successive models of the 9.5mm Minox up to the Model C,

The 4-element Minox Complan design.

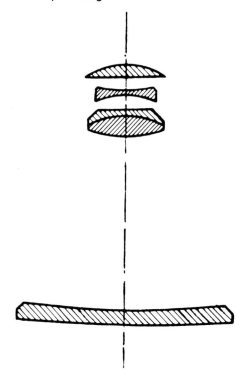

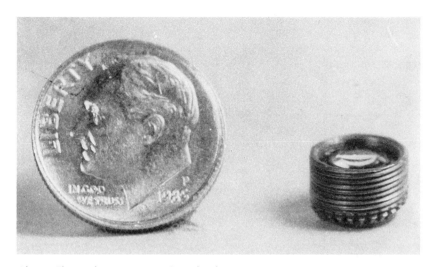

Above: The 4-element Minox Complan lens next to an American 10 cent piece. Shown approximately three times actual size. *Below:* Arthur Seibert (1906-1980, designer of the early post WWII Minox lenses, including the famous 4-element Complan. (Courtesy Liane Seibert and Family)

Ludwig Rinn (1869-1958), partner in the Rinn and Cloos Cigar works and one of Giessen's most famous city fathers. (Courtesy Rolf Kasemeier)

when it was replaced by an improved design not requiring the curvilinear plane feature.

Seibert went on to found EMO-OPTIK-Arthur Seibert-Wetzlar in 1951, a firm known to this day for its very fine high-quality optics, including the Octoscop 8-combination pocket magnifier (2X to 28X), the Emoscop pocket-sized telescope, magnifier, microscope combination, the 3X Stereomax stereo viewing inspection spectacle, and the Macromax 5X +2 to −2 dioptre focusing slide and negative viewer with its color-corrected and coated lenses. Seibert died on 11th November 1980.

Early in 1947, the Zapp-Jurgens Bahnhofstrasse Minox operation had come to the attention of Ludwig Rinn, an industrialist in the Giessen/ Wetzlar area. Rinn, who was born on 17th March 1870 in Heuchelheim, a suburb of Giessen, had attended the Realschule in Heuchelheim and Giessen in 1876-1887. Since 1931, he had been the head of the firm Rinn and Cloos, tobacco merchants. The tobacco firm had grown out of an earlier venture called Heyligenstadt AG, a machine tool manufacturing firm. Rinn had also held office as "Handelskammer" (head of the Chamber of Commerce) in the Giessen area, and was a very well

respected business man and philanthropist. Rinn's factories were ravaged by the air raids on Giessen in the Spring of 1945, and after the war Rinn desperately sought diversification to recover his losses as rapidly as possible. The fledgling Minox camera was the talk of the Wetzlar optical community in 1947, and Rinn offered Zapp an empty hall in the tobacco factory in which to commence larger scale Minox production. Rinn was a born entrepreneur and had taken many business risks in his lifetime. He felt justified in gambling on this most novel of photographic instruments. Many of the earlier runs of the postwar Minox II's originated in this cigar factory hall. The Minox operation eventually expanded to a larger establishment closer to Giessen which employed 600 people in the mid-1950s as sales for the III-s peaked and the Model B was introduced.

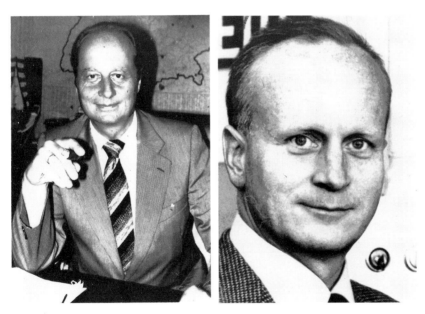

Left: Klaus Rinn, present chief executive of Minox GmbH and grandson of Ludwig Rinn. *Right:* Jurgen Rinn, brother of Klaus Rinn, and officer of Minox GmbH in the 1955-1975 era.

CHAPTER 5

The 1950s — The Influence of Donald O. Thayer Snr.

The time was right in 1949 to look at postwar American importation and distribution. Early U.S. postwar ads for the Minox II appeared in *U.S. Camera, Popular Photography, Photo Dealer*, and other journals in 1950. U.S. Minox operations at this time were divided between 89 Broad Street and 140 East 30th Street, a brownstone-fronted apartment house in New York City. The first address was mainly an importing office and the second was an uptown center for sales and distribution. Janis Vitols had resumed business in the style of Minox Inc. which had originally been the name of the American business in prewar years. In 1948, Gerd Sause, who was commercial manager of the Rinn cigar business, had been calling on some of the Army Post Exchanges in connection with cigar and tobacco sales. It was at one of the Exchanges that Sause met Donald O. Thayer Snr., whose responsibilities included buying novelty goods. Thayer's subsequent activities were to change the entire Minox situation in the United States, and indirectly throughout the world. Through Sause and Thayer the network was completed back to Zapp, and then to Vitols in the U.S. Thayer was exceptionally enthusiastic about prospects for U.S. sales, and had already organised trips to Lugano, Switzerland in 1948 and Zurich in 1949, in attempts to see Otto Rusche and clarify the VEF-AG Swiss end of Minox operations, which could have presented some obstacles to the legal importation of American Minox shipments.

The year 1950 brought many mixed signals for Minox activity. In a letter dated 3rd July 1950 from Zurich, Thayer had mentioned that Zapp and Jurgens would be severing their formal and legal ties to the Rinn cigar factory operation. This operation was without a technical manager, although a Professor Josef Stuper was temporarily acting as head of Minox technical affairs there. In the same letter Thayer expressed his willingness to come to the United States and work for Janis Vitols for $100 a week and expenses, and to do anything necessary to ensure the success of the Minox in the U.S. The Swiss operations had been bothering Janis Vitols during this time. During the 1948-1950 period, the matter of

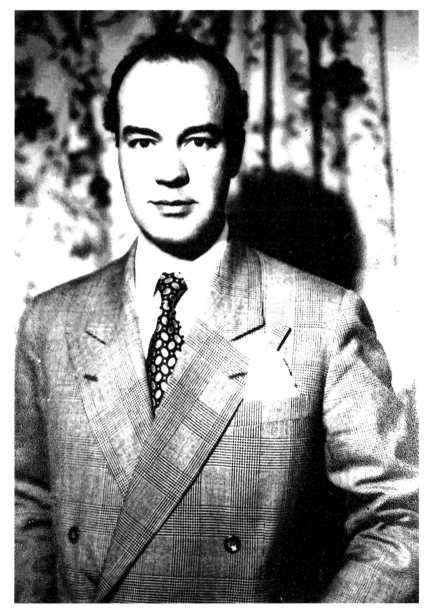

Donald O. Thayer Sr., founder of Minox Processing Laboratories, and the person most responsible for the success of the Minox camera in the United States. Picture taken mid 1940's. (Courtesy Thayer Family)

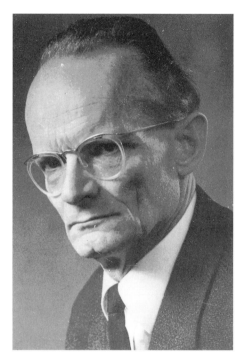

Walter Zapp, primary inventor of the Minox camera. Switzerland, October 1966. (Courtesy Walter Zapp)

the 40 crates of VEF Riga Minox parts, stored in a Zurich warehouse during the war, came up when Zapp talked to Engel, Rusche's son-in-law, in hopes of securing the parts for postwar use. With the introduction of the Model II in late 1948, many of these parts were useless, and only a portion proved salvageable, accounting for some hybridization of parts from Riga Minox's and early Model II's.

The break between Zapp and the Rinns came at the beginning of 1950 when Fritz Baumgarten was installed as factory manager at Minox GmbH (Rinn's). Zapp's role in the first 16 years of Minox history and technology, and thereafter at times as a consultant, must merit his place forever as one of the great innovators in photography. None of the recent so-called pocket cameras have ever shown the degree of original thought embodied in the Minox, and very few subminiature cameras throughout the 150 years since Steinheil and Daguerre have remotely approached the Minox in capabilities.

In January 1950 Vitols was well on the way to 100% control of Minox

Inc. (USA), with Don Thayer Snr. as his chief salesman, although in 1954 Vitols was to sell his control over Minox Inc. back to Minox GmbH in Germany. In the meantime, at a 1953 Trade Show in Cleveland, Ohio, Thayer's booth happened to be located next to the booth of Kling Photo Corporation, a large distributor of speciality photographic and camera goods. A casual conversation between Kurt Luhn, Vice-President of Kling, and Thayer led to Kling's acquisition of the distribution rights for Minox in the U.S.A., but Thayer-Vitols retained sole direct factory importation control.

One more interesting development occurred in the 1950-1952 period. Zapp had approached Arde Bulova, son of the founder of the Bulova Watch Company, in the hopes of interesting him in the manufacture of the Minox, perhaps in the United States. Zapp had even come to the U.S. for a six weeks visit in this period but returned home without succeeding in finding an American backer. With the reversion of Vitols' shares in Minox back to Minox GmbH, and the increased sales activity in 1953, the die had been cast for Minox GmbH to become the permanent manufacturer.

From conversations while he had been with the PX Service in Europe, Thayer had earlier realised that Minox processing would not only be a

Kurt Luhn, Vice President and Marketing Manager of Kling Photo and partner of Paul Klingenstein for 40 years. (Courtesy Kling-Berkey Archives)

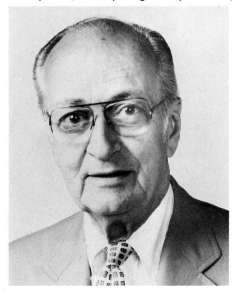

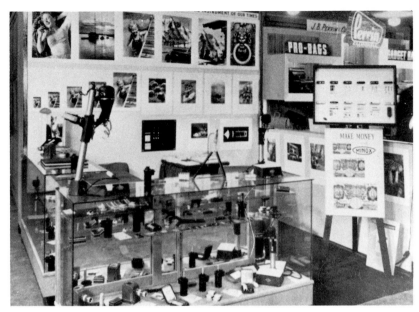

A mock-up dealer showcase for Minox goods, set up at a photographic trade show in 1951. Note the slant column enlarger on the left and two vertical column enlargers (one inside, and one outside the showcase) on the right. A copy arm variant that looked like a monkey wrench is in the top center of the case. Also note one of the very early prototype demonstration assembly boards in the upper right corner. Two Hollyslide projectors appear in the lower left of the case and developing tanks are all over the place.

key factor in the success of the American Minox venture, but would also be one of its most profitable aspects. The beginnings of the Minox Processing Laboratories venture began at 107-14 71st Road in Forest Hills, Queens, New York. Minox Corporation which had been chartered on 12th March 1954 from Vitols' old style of Minox Inc. was later changed to Don. O. Thayer Inc. on 28th December 1955. Don Thayer Snr., born on 4th August 1918 in Kansas City, was the son of Rupert Thayer, a switchman for the Atlanta, Topeka, and Santa Fe Railroad. Thayer had spent his early years in specialty sales, and was part-owner of a venetian blind manufacturing company in Kansas City in 1940. He had also travelled throughout the mid-West, cultivating specialty sales in men's clothing and apparel shops, and part of his sales strategy after the war involved placing the Minox in jewelry, as well as specialty photo-related sales outlets. The postwar Minox connection was fertile ground for Thayer, a born salesman.

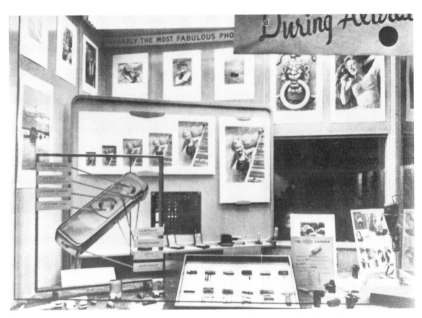

Above: Window display, built up around Model III, late 1951. One of the very earliest demonstration assembly boards can be seen in the center foreground with four tanks and a slant column enlarger at the far right. *Below:* Paul Klingenstein, President of Kling Photo, a major distributor of Minox goods during the 1954-1974 era. (Courtesy Kling-Berkey Archives)

The brownstone house on 140 East 30th Street, New York City, headquarters for Minox Inc. during the 1950-1954 era and the office from which the first Vitols-Thayer operations were conducted.

The earliest attempted lab set-ups were in the form of crude loop processors, but loop processing for film of such narrow width as the Minox was prone to scratching. Eventually the negatives and transparencies were batch-processed under strict quality control, a practice that continues to the present day. There were only three employees at the beginning, one of whom was Thayer. Printing was semi-automatic, with colour enlarging done virtually on a custom basis, but at popular prices. In the early days, from 1954 to 1955, much of the business was solicited through ads in *Photo Merchandising* magazine, a trade journal. There were no return-mailing bags, and definitely no automated record keeping. The dealer-oriented ads were soon supplemented in 1956 with ads directed at the consumer in mass circulation magazines like *Popular Photography*. By 1957, the number of employees had grown to over 50, and turn-round times had shrunk from 10 days to 3 or 4 days. Early enlarging paper was mainly in eggshell finish, but by 1958, a choice of gloss and semi-matte was common, and the customer had only to tick the appropriate box on the mailing bags. Don Thayer Snr. did not believe in extra charges for fancy finish papers, and all print finishes cost the same.

Always heedful of the requirement for increasing sales, Thayer

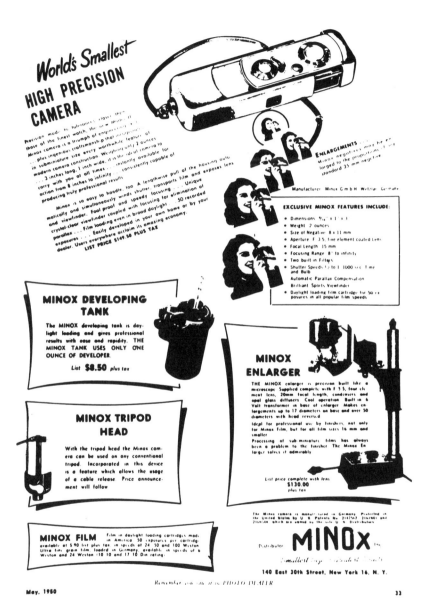

May 1950 advertisement for the post WWII Wetzlar and early Giessen-Heuchelheim goods. The woman in the advertisement is Mable Vitols, wife of Janis Vitols. (Courtesy Photo Dealer magazine)

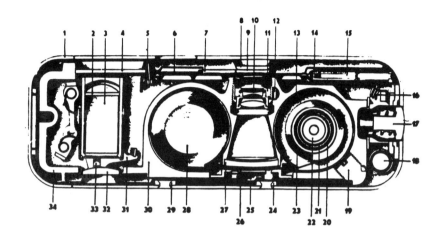

Section through the MINOX, twice full size.

1 Case	12 Spring	23 Axle
2 Mirror of viewfinder	13 Film magazine	24 Stop
3 Viewfinder	14 Shutter spring	25 Pressure plate spring
4 Protection glass	15 Shutter spring anchor	26 Pressure plate
5 Release pin	16 Spring of the lid	27 Film lens
6 Shutter blades	17 Lock	28 Film magazine
7 Filter	18 Film transport spring	29 Pressure plate cam
8 Protection glass	19 Screwed stop	30 Camera body
9 Filter	20 Spring	31 Lever
10 Objective	21 Take-up axle	32 Viewfinder eyepiece
11 Objective mount	22 Take-up wheel	33 Axis of rotation

34 Camera body (injection moulding)

MINOX G. m. b. H., WETZLAR
GIESSEN-HEUCHELHEIM WORKS
GIESSEN, POSTFACH 137

Printed in Germany

Cross-sectional view of Minox II

conceived the *Minox Memo*, the house organ, in 1955. The first issue, Volume 1, Number 1, came off the press in Spring 1956, and included stories about Alfred Hitchcock and Shirley McLaine, both with Minox tie-ins. The same issue announced the first printing of the classic work on the use of the Minox, "Small Minox - Big Pictures", by Rolf Kasemeier, then Marketing and Promotion Manager of Minox GmbH, Giessen. Invitations and forms for starting up Minox clubs appeared in the *Memo*. In the years up to 1972, when publication ceased, the *Memo* featured all sorts of unusual stories with the Minox as the central theme. The second issue in Winter 1956/57 announced the first annual Minox photo contest with ten awards in each of the two divisions – "Pleasure" and "Business". First prizes were inscribed trophies with "gold" Minox

Donald Thayer Jr., present owner of Minox Processing Laboratories, who assumed responsibility for the business on the death of his father in 1968.

Early price schedules for Minox processing circa 1954.
(Courtesy Photo Dealer Magazine)

cameras mounted on top, and additional early electronic Minox flash with the power pack in the binocular-styled leather cases. In late 1956, in the first of several user surveys, Minox user habits were investigated. Out of 2000 owners surveyed, 1282 replied, and the largest group came under what Minox called "executive classifications". These included presidents of corporations, sales managers, and buyers, and totalled 375 users. The next group, the professions, showed a total of 257, with

Part of a series of advertisements run in Photo Merchandising magazine in the 1954-1960 period, soliciting dealer participation in Minox Processing Laboratories business.

NOW you're ready to start your Minox club

This is to certify that

is a mite-y Minoxer and a
Master of Minoxology

Official Minox Camera Club of

city _____

president _____

date _____

Write in today to Minox Processing Laboratories, Forest Hills 75, New York for your supply of Minox Club Membership Cards.

This notice to start up your own Minox Club appeared in the early runs of the Minox Memo.

doctors (M.D.'s) making up 110 of that total. The third group, scientists and engineers, accounted for a total of 119 users.

Although this survey was by no means exhaustive, it began to point up the need for more intense sales efforts in the area of accessories. The tabulation of the survey appeared in the Spring 1957 *Memo* alongside the announcement of the Minox B-C flash, one of Don Thayer Snr.'s ideas. In the same *Memo* was the announcement of the Minox Flash Adapter Shoe which enabled the early Minox Electronic Flash and B-C flash to be used with cameras other than the Minox. The Summer 1957 issue highlighted a recurring use of the Minox — that of an author or researcher needing a pocketable camera that could be used in available-light situations such as libraries or archives. Shown in this particular *Memo* was Jay Williams, author of the novel; *The Witches*, published by Random House in 1957. The next pages introduced the Minox exposure meter and the early Model 30 HP projector. Even J. Edgar Hoover of the F.B.I. made an appearance in this Summer 1957 issue. Summer 1958 featured the great Elmer Wheeler, who coined the advertising slogan "Don't sell the steak — sell the sizzle". Wheeler's ploy was to take Minox pictures and then send them to his clients for what he called

"remembrance value". The Minox was a great drawing card, selling Wheeler, and as Wheeler tells it, selling the Minox itself. Wheeler even mentioned the Minox in his book, *How to Sell when the Selling is Tough*.

The Minox B, announced in mid 1958, was written up in the Summer 1958 *Memo*. Efrem Zimbalist, the actor who was appearing in TV's Sunset Strip, made an appearance in the Fall 1959 issue of the *Memo* which also explained the use of the Minox in exploration of underground tombs. The actual color photos from the Minox used had been reproduced in the September 1959 issue of the *National Geographic* magazine. The third Minox contest was opened. Winter 1959 showed John Foster Dulles, U.S. Secretary of State, in a Minox picture that was taken by his wife in France in 1955. For Christmas shoppers, the Winter 1959 issue also featured a two-page, very fine print listing of all Minox dealers in the U.S., including Hawaii and Puerto Pico. Over 1100 stores were on these two pages! Tips on forming Minox clubs were in the Summer 1960 issue, and Spring 1961 carried a photo of Nikita Kruschev of the USSR, as photographed by Edward Steichen. Occasionally an undercover use of Minox would be in the *Memo*. Just such a photo, on illegal gambling, from Salt Lake City's *Utah Desert News* won first prize in the Business division of the Minox Contest, and was reproduced in the Spring 1961 *Memo*. The Winter 1961 *Memo* re-emphasized accessories and included details of enlargers, telephoto binocular clamps, slide binders, tripods, and accessory filter kits.

The 4th Minox Contest was three months old when the Summer 1961 issue was sent out, and the first official Minox Club in New York City was announced in the same issue. Spring 1962 called attention to the closing of the 4th Contest and a few pages later announced the Minomat automatic slide projector, an improvement over the first Model HP 30 which had no auto-focusing or remote control. Summer 1962 featured the Shah of Iran being "shot" with a Minox by Red Skelton, the famous American comedian. Not to be outdone, there was a Minox photo of Mrs. Indira Ghandi taken by an amateur Minoxer from Baltimore, Maryland who had captured the Indian leader on film while she was visiting Washington D.C. The Winter 1962 issue brought photos of Albert Einstein, Sarah Bernhardt, and Gloria Swanson – all part of the book written by L. Fritz Gruber, world famous host of so many of the German Photokina Trade Shows. The winners of the 4th Minox Contest were also announced in this issue.

During a period from 1962, several changes took place in the marketing strategies for Minox. Between 1962 and 1964, Minox GmbH, Giessen, attempted to set up its own distribution system within the

United States, in conjunction with Don Thayer Snr. This plan fell through, and on 12th December 1964, Minox Corporation, the interim organization set up by Minox GmbH as its potential new distributor, was acquired by Kling Photo as a wholly-owned subsidiary of Kling. Kling had been the distributor since the 1953 arrangement made with Don Thayer Snr. and they now resumed full distributorship in Winter 1964. The Minox Processing Laboratories continued under Don O. Thayer Snr. as the only Minox GmbH factory-authorised processing facility in the United States. Despite the new formalities, relations continued to be friendly between Kling and Thayer. Financial restructuring did lead to Kling's support for the *Memo* being discontinued, with Thayer continuing the *Memo*, and Kling-Berkey issuing their own *Minox Letter* as part of the new Minox Corporation operation from 1967 to 1971.

The Minox *Memo* inspired a parallel publication by the Minox GmbH factory called *Der Minox Freund* (The Minox Friend) which ran for 20 issues beginning in November 1958 and ending with the introduction of the Minox Model C in 1969. The first issue came on the heels of the Minox B, and included an explanation of the parallax mechanisms used for the Minox. The back cover of each *Freund* carried a running summary of the current Minox line of accessories. Issue number 4 carried photos of a model wearing an actual Minox B as an earring, and one as a full

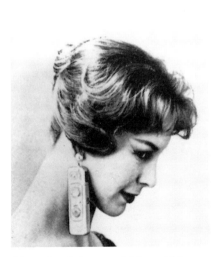
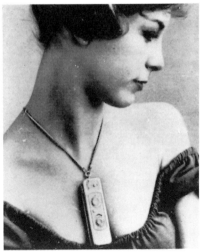

Mary Ann Lejoy, model from Chicago, wearing full-size Minox B as an earring and as a neck pendant.

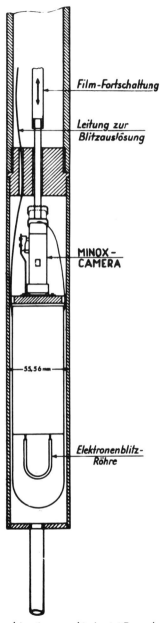

Schematic of Minox/Flashtube combination used in Lerici Foundation archeological explorations.

The Lerici apparatus about to be inserted in the well tube.

size pendant on a chain. The model, Mary Ann Lejoy of Chicago, later said that she only began to notice the weight of the Minox after four hours of modeling – after all, it weighed barely 3½ ounces! Alfons Gorisch, a chimney sweep, told his story of using the Minox to document the interior conditions of the chimneys he inspected for his customers. Many stories were relayed across the ocean from the *Freund* to the *Memo* and vice versa. Issue 6 of the *Freund* in September 1960 reprinted the *National Geographic* archeological photos in black and white, and gave details of the probe and flash used by Professor Lerici, who led the team. Issue 12, in December 1962, devoted five pages to the selection of binoculars, and their application to tele-Minox-photography. The following page carried a photo of Jackie Kennedy and her sister, Princess Lee Radziwill, both holding Minox cameras. The new colour transparency film Minochrome 13 Din was featured with many colour photos in Issue 15 of April 1964, and was highlighted during a projection show held at the Hanover Fair in Spring 1964. If the reader was attentive, the back cover of Issue 19, in September 1968, told him that the 15-packet chemical processing kit had been replaced by the new 5 ampoule package, with a photo and story on page 9 of that issue which gave the reader all the details.

The Growth Era — late 1950's to the mid 1970's

Until 1958 the Minox had no integral exposure meter. The photographer either used a hand-held meter or bought the accessory meter made by Gossen for Minox. The Gossen Minox meter had been introduced in late 1953, and utilized a selenium cell and a rotating roller scale for matching ASA speeds. Gossen's success in developing the separate exposure meter prompted Minox GmbH to have Gossen design the tiny meter and cell combination that was utilized in the Model B. Selenium cells from early

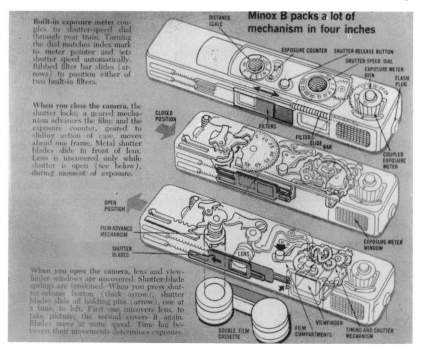

Reprinted from Popular Science with permission, © 1963 Times Mirror Magazines Inc.

Model B's still function within one-stop accuracy today, and only minor changes in cell design and the light gathering windows were made in later 1969-1972 production runs. The Minox B was an instantaneous hit when it was introduced in 1958, and for the extra ⅝in. (15mm) in length, assured the photographer of always having a meter in his hands as part of the camera. The added weight of the B over its predecessor, the III-s, was just under one ounce (about 25g). Over 100,000 III-s cameras were produced between 1951 and 1969, whereas three times that quantity of the Model B were produced between 1958 and 1969. The Model B was by far the most popular of the 9.5mm Minoxes and the factory had been forced to go on double shift for its production – an unprecedented event in the annals of Minox GmbH.

The years from 1955 were truly growth years for Minox GmbH and the Minox as the system camera that Zapp had envisaged. A Minox electronic flash unit was introduced in late 1956. It weighed "a mere 24 ounces" (680g) and featured a fan-fold reflector with the electronics in a binocular-shaped leather case. Up to this time flash accessories had

Entrance to Minox GmbH, Ludwig Rinn Strasse, Giessen. Peak employment was over 1100 people in the period 1953-1960. (Courtesy Rolf Kasemeier)

Factory test stand to determine resolution of Minox 35ML lenses. A similar set-up was used to test all post WWII 9.5mm Minox lenses. Factory records of the serial number of a lens and resolution negatives were kept on file for quality control.

utilised flashbulbs. Also added to the line was a slide projector and additional copying and enlarging equipment. Developing tank designs were modified, right angle and reflex auxiliary finders were introduced, and albums, folders, and novelties such as the "Diplomat" fitted cases were conceived. A variety of leather cases came on the scene, including loop cases that allowed the user to carry the Minox on a belt. Binocular clamp adapters for telephoto work were featured and although the Minox had a fixed, non-interchangeable lens, no one could accuse the manufacturer of not wanting to supply enough accessories to make the camera every bit as versatile as the current 35mm cameras.

One of the most popular sales gimmicks during this period was the Minox "speed demonstration". Irwin Feher, the then Vice president of Minox Inc., became a legend in having a finished print ready within 12 minutes from the time that the potential Minox buyer had his picture taken!

The next major stage in 9.5mm-format Minox design was the Model

Above: A video camera autocollimator test set-up for checking 35mm camera lenses. *Below:* Grinding lens elements for the 9.5mm Minox lenses

C, introduced in late 1969. The camera was in production until 1976, and over 160,000 were manufactured, making it the second most popular model after the Model B. The C was a major step forward in offering full exposure automation, incorporating an electromagnetically-timed shutter, coupled to a CdS photocell. One unique feature of the C allowed previewing, with an indicator light for exposures longer than 1/30 second. Another first was that the film in the C was advanced only if the picture was taken. The counter on the C indicated how many exposures were left, unlike the counter on the B which told the user the number of exposures that had already been made.

The C was the subject of at least two contest promotions, the first of which occurred in late 1969, offering a C as first prize, and $25 worth of processing coupons as prizes for the runners-up. A second contest in Summer 1972 offered ten C's, the recipients determined by winning numbers on a special promotional processing return envelope. Campaigns in 1972 featured prominent personalities using the C. One of

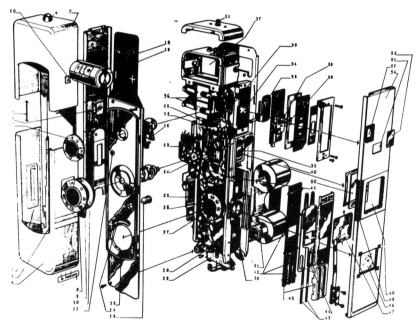

An exploded view of the Minox C.
(Courtesy Phot'Argus (R), le Magazine Professionnel des Techniques de l'Image, 116 Bd Malesherbes 75017, Paris, France © Copyright 1972)

Advertising dealer mats for the "Bring Back Your Minox B" campaign - an effort to sell more Minox C's in early 1971.

these was Herbert Baker, owner of the advertising agency which did much of the ad work for Minox in the mid 1950's and 1960's. The agency and Minox were honored in 1955 with a *Modern Packaging* magazine award for the innovative and colorful Minox film packaging, and high visibility point-of-sale displays for Minox goods. One other promotional effort in connection with the Model C was the 1971 work of Kurt Luhn, Vice-President of Kling, whose idea it was to offer dealers "day-glo" fluorescent-coloured signs and advertising news mats with the theme "Bring Back Your Minox B". The dealer was given two options when the customer brought back a B for trade-in towards a C. Each option allowed the dealer a chance to resell the B trade-in as a refurbished camera with new packaging and limited, factory-backed guarantee. The impact of the C was such that, one year after its introduction, it was estimated that only a third of all B's produced were still in their original owner's hands.

The Minox 110S, introduced at the 1974 Fall Photokina, was intended to be Minox's answer to the high-end Kodak Instamatic 50 and 60 introduced in 1972. The 110S had some interesting mechanical and

optical features. Weighing only 5oz(about 140g), it was the lightest of all 110 cameras at that time to have a built-in rangefinder. A pair of alligator-like front doors provided a combination of lens protection and partial sun-shading. Safety interlock features were incorporated to minimize battery drain when the doors were closed and the meter shut off. The rear door design had a "scratching" device which renewed the contact surfaces of the battery each time a new cassette of film was put in the camera. The viewfinder incorporated a slow shutter speed/camera shake warning signal, as well as an overexposure warning. There was a built-in socket for a flash cube, but an electronic flash unit was also offered as an accessory. The 110 craze began to diminish in the late 1970s, and by 1980, the Minox 110 was becoming a memory. A simpler model, the 110L with a f/5.6 lens, never made it into the market place.

The Model BL, manufactured in limited quantities between 1972 and 1973, was an interesting modification to the B, produced while the C was still in its infancy. The advantages offered by the CdS cell employed in the C design were incorporated in the BL in the form of a match needle meter. It was priced attractively against the C, whilst being a little ahead of the B in eliminating a step in interpreting the meter reading.

TINY MINOX WELCOMES SMALL KODAK INSTAMATIC TO THE WONDERFUL WORLD OF MINIATURE PHOTOGRAPHY.

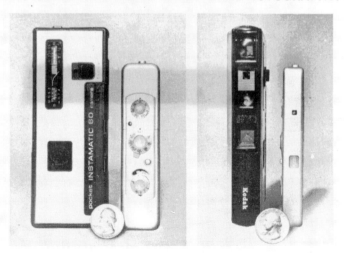

The Minox C welcomes the product from Rochester!

Early in the BL years a 1972 ad compared the BL to a Kodak Instamatic 60 camera to make the point about which was the most compact camera. It is an interesting coincidence for collectors that the number of BL's produced – approximately 17,000 – closely approaches the figure for production of the VEF Riga model.

The Later Years
(1974 to the Present)

The Minox LX, introduced in 1976 and still in production, became the high-end design of the 9.5mm Minox series. It took the features of the Model C one step further in a body that was only 4¼in. (108mm) long − half an inch (12mm) less than the C. Compared with the C, the LX extended the auto shutter speed range from ¹⁄₁₀₀₀ to ¹⁄₂₀₀₀ sec. at the fast end, and from 10 to 16 sec. at the slow end. The LX has coloured warning lights; yellow signals low light conditions and warns of long-exposure; overexposure is indicated with a red light, which is a reminder to use the built-in 4X neutral density filter; and a green light signals the condition of the battery. The LX exposure counter reads from 36 down to zero, indicating the number of exposures remaining. The flash circuitry of the LX is further automated, with the shutter closing at the exact instant when a flash cube has given the right amount of light, or setting the correct synchronized shutter speed with electronic flash. Two distinctive features of the LX are spring ejection of the cassette, which eliminates the need to "tap out" the cassette as in former models, and the shutter release which is a bar shaped to the contours of the finger. The periphery of the setting wheels are knurled, instead of the long familiar dimpled and knurled centers of earlier models. In 1988, in commemoration of the 50th Anniversary of the first 1938 production run in Riga, a limited edition of 999 gold LX cameras was issued in fitted hardwood boxes. The choice of 999 units was arrived at as a subtle reminder to both workers and customers that precision optics and mechanics do not always result in easy and even numbers of production units.

The EC, introduced in 1981, is also still in production and is the smallest of all Minox cameras ever produced. Measuring 80x30x18mm, the EC weighs 58 grams − a little over 2oz − with battery and film. The four-element lens is a departure in being of fixed-focus with maximum aperture of f/5.6, giving a depth of field from 3½ ft to infinity. The shutter is fully coupled, giving automatic exposure control once the film's ISO

THE MINOX EC IS THE TINIEST
OF ALL THE TINY MINOX CAMERAS

Nobody could accuse Minox of overstating their case in this simple piece of advertising for the EC.

speed is set by a knurled control. With ISO 25 film, shutter speeds range from 8 to ¹⁄₅₀₀ sec., and a red LED warns of potential slow-speed camera shake conditions, and the need for flash. The EC found itself on the consumer's buying map after a very clever introductory promotion through the American Express Charge Card system. This campaign was the brainchild of Don Thayer Jr. who worked-in ample processing tie-ins to appeal to many EC buyers. Don Thayer Jr. continues to carry on the traditions in service, quality, and innovation that his father first introduced to Minox users over 30 years ago, and the present Thayer organization includes full-time in-house repair facilities, as well as the very latest in processing equipment for Minox users.

The introduction of the first 35mm Minox, the 35 EL, was accompanied with much fanfare at the 1974 Photokina. Although the pertinent German patent No.3020340 for the folding design was not issued until 1980, the key to Minox's claim for the 35 EL's being "the world's smallest full-frame 35mm camera" lay in the ingenious front flap and lens configuration that allowed the body to be extremely thin when collapsed, and very shallow in depth when the lens was in the open position. This patent, by Helmut Knapp of Bibertal, West Germany, showed considerable ingenuity compared with similar Japanese designs filed by Fumihiro Miyagawa and Kousaku Sawabe for Ricoh in 1978.

From 1974 to the present day, Minox has produced over eight different models of the 35mm camera, and they are described in the second part of this book. The most definitive book on Minox 35mm technique and operation has been written by Rolf Kasemeier, former

manager of marketing, advertising, and promotion at Minox GmbH. Kasemeier's book; *Minox 35* is published by G+G Urban Verlag, Munich, West Germany, and contains almost 200 pages on the technique and technology associated with the 35mm line of Minoxes. Kasemeier was with Minox from 1950, and is one of the few people in the world intimately acquainted with all Minox activity over the past four decades.

Moving into an electronically-sophisticated, compact 35mm format was a very difficult transition for Minox. The Japanese dominated the field and they were a hard act to follow. Early runs of integrated chips for Minox 35's presented many surprises in reliability and quality control. 1986 was an especially bad year for shutter and electronic problems in the 35mm series, and delivery failures by subcontractors compounded headaches even further. Over 100 workers were laid off, or retired early in 1987. Much of the shutter production had to be jobbed out to others, under strict Minox factory control. In 1987, Minox was the last German-owned manufacturer of both miniature and subminiature cameras; Leitz having passed into Swiss ownership. The company had a gross income of 60 million marks and employed just over 700 workers. Ninety percent of 1987 production was 35mm models, and constituted 80% of the total annual camera income. Forty percent of camera production was exported in 1987. During that same year, the Heyligenstadt Machine Tool Works, one of the cornerstones on which Rinn and Cloos had been built, was sold to the Tong group in South Korea. An earlier move towards developing information-handling technologies was driving the microfilm activity up to 20% of total gross income in 1986.

Microfilm apparatus had also been part of the Minox line, and one of the earliest post World War II microfilm-related activities of Minox GmbH was the construction of approximately 70 "Mikrodot Gerat" units. Described and illustrated in Part 2, these units produced microdots for the Western intelligence community. Later, in the 1950's and 1960's, Minox manufactured conventional microfilm and microfiche readers, as well as microfilm cameras, many of which are also described in Part 2. Minox GmbH also furnished microfilm equipment for the Moscow, U.S.S.R., telephone exchange, which employed about 500 operators using microfilm readers in the office alone.

In late 1988 the company underwent a financial restructuring but, contrary to rumour, production continues and Minox GmbH enters the 1990's still producing the LX and EC, descendants of Walter Zapp's brilliant design of 50 years ago.

CHAPTER 8

"Spycamera"

The makers of the Minox have always maintained a neutral position in their advertising insofar as the use of the Minox for espionage is concerned. They have never claimed its suitability for surreptitious photography as a reason for designing it, or as a "consumer benefit" in marketing it. Nevertheless, its story cannot be complete without an account of some of the famous, and some less well-known occasions when it has proved its entitlement to the epithet "spycamera".

In early May, 1940, John Moore-Brabazon, later Lord Brabazon, a Member of Parliament, aviation pioneer and member of the board of Kodak Ltd. secretly took the first ever photographs of the House of Commons in session with his Minox. Photography was, and still is, forbidden in the House when it is in session. The pictures were snatched, in poor lighting, so many were underexposed or blurred from camera shake, but those which are printable are of great historical importance. The London *Sunday Times* published three of the pictures on 1st May 1966, after first showing them to R.A. Butler, who had been present and appears in the pictures, but was unaware of Brabazon's clandestine activities. He identified the occasion as the crucial debate on the disastrous Norwegian campaign when Hitler's armies were sweeping across Europe. The debate took place in the momentous three days before the fall of the Chamberlain government on 10th May 1940 over its conduct of the war. Besides being a historic use of the Minox, these are the only known pictures of the Commons in session in its old chamber, which was to be destroyed in an air raid in 1941, and of Winston Churchill in the House.

Brabazon's personal papers indicate that he was one of the earliest purchasers of the Latvian Minox camera to be imported into England in 1938. Interviewed a few years before his death in May 1964, Brabazon confided details of the House of Commons photos to a friend. They were taken mainly from the Bar of the House but also from the Speaker's end, while standing, but Brabazon was interrupted at one point by a

suspicious usher. Seeing the usher approaching, Brabazon slipped the Minox into his pocket and substituted a cigarette lighter for it which he took out of his pocket and rubbed on his nose to further allay suspicion. The usher withdrew, none the wiser to Brabazon's daring photographs. The House of Commons Minox negatives are in the Royal Air Force Museum Collections. The film is still in its original VEF Riga tin but is in three pieces. The House of Commons pictures were taken on two separate occasions, which might have been just a few hours apart, because the series of 29 Commons shots is separated only by a few frames of trees and a figure in a room.

In another twist the Minox really was part of a cigarette lighter, devised by Clayton Hutton, a member of Britain's famous WWII MI 9

The crowded and attentive House of Commons, recorded by the late Lord Brabazon, during the intense debate in the crisis days before the fall of the Chamberlain government on 10th May 1940. Winston Churchill then became Prime Minister and formed his wartime coalition government.

Below: Winston Churchill can be readily identified sitting in the middle of the front bench. On his left is Neville Chamberlain, the Prime Minister, who was shortly to resign. On Chamberlain's left is Sir John Simon, Chancellor of the Exchequer, and on his left Sir Samuel Hoare, Air Minister. In the second row, third on the left from the standing figure, is the late R.A. Butler who identified the occasion when the negatives came to light a quarter of a century later.

Above: The Prime Minister, Neville Chamberlain, addressing the House, possibly his last speech as premier.

Below: The Opposition benches listen intently - several are in uniform.
(Courtesy Royal Air Force Museum and Lord Brabazon of Tara (grandson of the photographer). Pictures printed from the original negatives for this book.

SECRET
OFFICE OF STRATEGIC SERVICES
WASHINGTON 25, D. C.

Lieutenant Frederick A. Spencer April 25, 1942

Major David Bruce

Minox Cameras

 Please be advised that the 25 Minox
cameras, 104 rolls of film, and 2 enlargers were
delivered to your office today.

 According to our conversation of
Friday morning, I believe you would like to
have a total of 50 of these cameras, which
means that you would like to have 25 more.
Please advise me if this is correct and I
will go about combing the country to locate
them as you know they are very scarce.

 We managed to locate 6 cameras in
New York, which will be delivered here Monday.
This will then mean that you will have a total
of 31. I have wind of a shipment of these
cameras from England, so if you wish any more
than the 50, please advise me further. I be-
lieve the purchase price will be the same, al-
though several dealers knowing the scarcity of
these cameras are trying to boost the price due
to the law of supply and demand.

 Please advise all the persons to whom
the cameras are assigned to read very carefully
the instructions, as these cameras are precision
instruments and unless all directions are carefully
followed the best results will not be obtained.

 Any men that you wish to have instructed
in the use of these cameras or of any other camera,
please advise me and I will send a photographic
officer to give them a short course in the
fundamentals of photography.

 Any way, shape, or form that this section
can cooperate or do any work for you, please do not
hesitate to call upon us.

Minox cameras were in great demand by all intelligence services in the war.

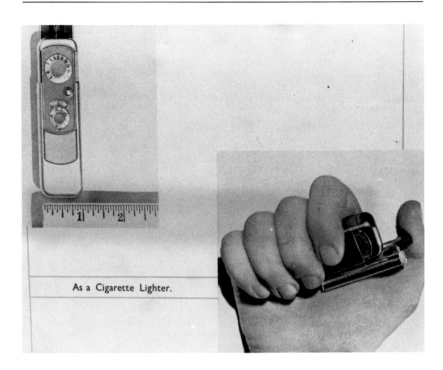

As a Cigarette Lighter.

The cigarette lighter Minox designed by Clayton Hutton, member of Britain's WWII MI9 escape group. (Courtesy MI9 Archives)

escape group. It was a cross between a Bowers-type lighter and a Minox camera and was manufactured in a very limited quantity by Messrs Blunts, instrument makers in suburban London. In addition to magnetised razor blades and coat buttons that could be used as emergency escape compasses, Hutton was the inventor of many other famous escape devices used later at Colditz and other prison camps in WWII. These even included a home-made camera, fashioned from field glass lenses and cigar boxes and used to make up forged identity documents.

On a macabre note, the Minox showed its capabilities in the November 1949 execution of James "Mad Dog" Morrelli, a notorious Chicago criminal. Executions had been surreptitiously photographed before, as in the case of Ruth Snyder, whose execution at Sing Sing Prison in New York state had been photographed in 1928, with a leg-strapped modified plate camera, by Tom Howard of the New York Daily News. The assignment for the Morelli execution photo was given to Joseph Berardi, a Chicago Herald American newspaper photo chief. The Cook County

jail warden had been boasting of a machine he had installed called an "Inspectoscope" which was an X-ray device to foil the entry of guns and other contraband. Berardi picked one of his best men; Joseph Migon (because in Berardi's own words "he had a lot of guts"). Joe Migon took a pair of his shoes to his shoemaker and had him cut out a recess in the heel for a Minox. The parade of witnesses filed into the execution room, and the Minox was deftly slipped out of the heel, under cover of a handkerchief, and the shot taken. The film was rushed back to the lab and the photograph made world headlines. When the warden later challenged Berardi and Migon that the picture was a fake, they re-enacted the entire routine, and convinced warden Chester Fordney that he had better improve on his detection techniques. It was a tribute to both Berardi and Migon that they had made a few test runs, unbeknown to the warden, just to make sure the X-ray beam did not go down as far as the heel and fog the film.

The 1962-1963 period also produced evidence that the Minox was still very much in vogue as a spy camera. Heinz Felfe, an intelligence

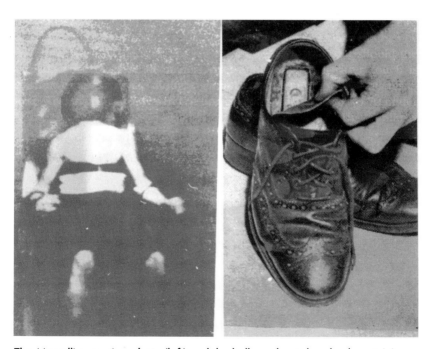

The Morrelli execution photo (left) and the hollowed out shoe heel containing a Minox (right). (Courtesy Chicago Herald and Joseph Berardi and Joseph Migon)

Minox grab shots taken by Metropolitan Museum of Art curator, Thomas Hoving, during pursuit of world-famous Cross of Bury St. Edmunds.
(Courtesy Thomas Hoving and Metropolitan Museum of Art)

officer in the organisation of West Germany's Chief of Intelligence, Reinhard Gehlen, was found to be a double agent for the Russians. During eleven years of serving Gehlen and West Germany, Felfe had photographed thousands of documents for the Russians. When apprehended, Felfe was carrying an attache case with a false bottom, over a dozen Minox cassettes, and a tape from the Minifon pocket recorder. Felfe had owned two Minox cameras and had a reputation for his expert use of the cameras.

A much more redeeming aspect of Minox use was the Lengede Mine disaster in West Germany in early 1964, in which a Minox with strobe was used to determine the conditions in the mine when it was impossible to free any of the miners in advance.

The Minox has been used in many movies; as early as 1948 by James Stewart in *Call Northside 777*, in the popular James Bond series, and as recently as 1980 in *Hopscotch* the story of a disgruntled CIA operative, played by Walter Matthau. But perhaps the most unique role ever played by the Minox in the world of art occurred in connection with an

acquisition by the Metropolitan Museum of Art in New York City. In the late 1950's, the Metropolitan had received indirect word that the long-sought 12th century walnut-ivory Cross of Bury St. Edmunds might be available for purchase. James Rorimer, then Director of the Museum, sent Thomas Hoving and Carmen Gomez-Moreno, two of his best curatorial staff, out on a chase that is described in Hoving's fascinating book *King of the Confessors*. The Cross was shown to Hoving under the condition that he did not photograph it with his Rolleiflex. Topic-Mimara, an ex-chief of Marshall Tito's post WWII Yugoslavian espionage service in West Germany, was the dealer offering the Cross. Snatching Hoving's Rolleiflex and temporarily leaving the room, Mimara thought he had Hoving at a loss as to photographic proof of the existence of the Cross. But Hoving had come prepared, and was able to record the Cross with a Minox, which he had kept in his pocket for just such a contingency. Armed with the photographic evidence, Hoving was able to convince Rorimer, and

Detail of Cross of Bury St. Edmunds, acquired in 1965, as a result of Thomas Hoving's persistent efforts and scholarship.
(Courtesy Thomas Hoving and Metropolitan Museum of Art)

Robert Perlee (left) and Leo McDonough (right) ready to lower downhole a camera system using a Minox, seen in the center of the cut-away tube, together with a pair of flashlight bulbs.

the Cross was purchased and listed as No:65.12 – the twelfth addition to the Metropolitan Museum in 1965.

Still more unusual applications of the Minox were coming to public attention. Earlier in 1973, scientists at the Los Alamos, New Mexico, National Laboratories were engaged in a project called "Subterrene". This was a peace-time application of nuclear explosives in which small diameter holes were being bored underground by high energy beams and directed explosions. Some means was necessary to inspect the quality of the surface of the inner walls of the holes that were created. Video cameras at that time were too bulky and delicate, and could not provide the resolution of detail required. An ingenious solution took the shape of an aluminium cylinder two inches in diameter. A section of the cylinder was cut away to expose a Minox, mounted in the center of the cylinder. The 8in. minimum focusing distance of the Minox was a design obstacle, until a system of mirrors was devised to provide a folded light

path of 17in. (432mm) in a length of 4in. (102mm). A pair of flashlight bulbs and a solenoid shutter trip completed the unusual underground camera. Power was provided by a cable which also acted as the lowering and raising device. Here was Lerici's idea again, only the application was in connection with the nuclear age.

In 1977, with the "Falcon and Snowman" case, the spycamera image came into the news once more. A Minox B was used by Christopher Boyce, an employee of the TRW Corporation, to film top-secret documents relating to satellite reconnaissance programs. The case was described in full detail in the book *The Falcon and The Snowman* by Robert Linsey, written in 1979. Crucial to the prosecution's case was the forensic evidence, painstakingly developed by Kent Dixon of the Federal Bureau of Investigation at that time. Dixon was an expert on questioned documents, tire tread, shoe print, and photographic-comparison evidence. He was able to match irregularities on the negatives carrying the compromised documents with irregularities present in a Minox B found

Kent Dixon, forensic expert, formerly with the Federal Bureau of Investigation, comparing framing marks on Minox camera used in the Falcon and Snowman espionage case. (Courtesy Kent Dixon and Federal Bureau of Investigation)

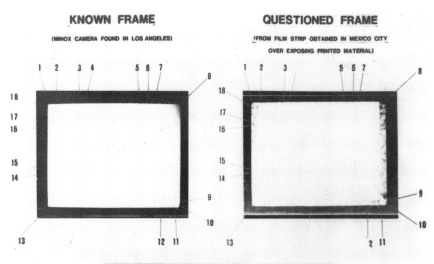

KNOWN FRAME

(MINOX CAMERA FOUND IN LOS ANGELES)

QUESTIONED FRAME

(FROM FILM STRIP OBTAINED IN MEXICO CITY
OVER EXPOSING PRINTED MATERIAL)

PHOTOGRAPHS ILLUSTRATE SOME OF THE POINTS OF
COMPARISON PROVING THE IDENTIFICATION OF THE
QUESTIONED NEGATIVES WITH THE MINOX CAMERA

Above: Known Frame v Questioned Frame
Comparison technique used by Kent Dixon to painstakingly identify Minox camera used in the Falcon and Snowman case. Eighteen separate marks were found and matched by Dixon.
(Courtesy Kent Dixon and Federal Bureau of Investigation)

Below: The "not just for beautiful spies any more" advertisement which sold a lot of black Minox LX cameras during Leitz-Minox distribution in the U.S.
(Courtesy Leitz Inc. U.S.A.)

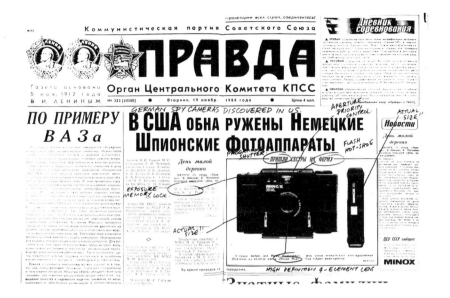

Above: Spoof on *Pravda* newspaper, run by Hasselblad U.S.A., for EC and 35ML. The author almost fell for it until he checked the date against the day of the week. One of the bright ideas of Bill Luckhurst, Hasselblad's Advertising Director. (Courtesy Hasselblad U.S.A.)

Left: John Walker, one of several people in the Whitworth-Walker Navy spy case which touched off world headlines in 1987. Walker is shown re-enacting his use of a Minox Model C. His technique earned him a life sentence in prison. (Courtesy Federal Bureau of Investigation)

in the bedroom of Daulton Lee, Boyce's friend and co-conspirator. The pattern of eighteen irregularities found around the picture frame, in front of the pressure plate of the Minox, matched those around the negatives. The prosecution was able to use Dixon's irrefutable proof to successfully convict Boyce and Lee. Dixon, now a private consultant in Crofton, Maryland, has a very unusual background in photo-intelligence of all kinds, and has even been successful in reconstructing vital evidence from broken and burnt matches.

Perhaps by coincidence or otherwise, a very clever brochure surfaced in 1979, issued by Leitz, featuring a female model with fedora brim over her eyes, and the caption *The Minox Spy Camera....It's not just for beautiful spies any more*. Inside the brochure showed a hand-tooled burgundy leather wallet containing a black LX, cube flash adapter, plus extra compartments for film cassettes and credit cards. Not to be outdone, the spycamera theme was echoed in 1981 in a series of ads by Hasselblad in *Petersen's Photographic Magazine*.

As a final closing development in the half century of Minox history, it was discovered in 1986 that the Minox spycamera role was acted out again. This time, it was the use of a Minox C by Jerry Whitworth and John Walker who were U.S. Navy communications specialists entrusted with cryptographic secrets. The pair, along with members of Walker's family, had systematically stolen vital defense information and, from as early as 1978, had divulged these secrets to the Soviets. Walker had used cigarette boxes and boxes for cotton swabs to hide the Minox cassettes. In 1987, Whitworth was sentenced to 365 years in prison, and Walker was sentenced to life imprisonment. The case was a dramatic world-wide reminder that, although its makers have always denied that the Minox was ever made for espionage, once again spies had chosen this famous, or perhaps infamous spycamera to assist them in the world's second oldest profession.

The 9.5mm Cameras

Any camera system that has survived for half a century must be right for its purpose. This part of the book describes in detail all known Minox camera models and variants, their accessories, and other Minox goods.

The Minox cameras that became part of the spy legend were those of 9.5mm format using film that is approximately ⅜in. wide. Special distinguishing features are highlighted for quick identification. A section on "gold" and other colored 9.5mm Minoxes is included, as well as an explanation of the Minox catalog numbering systems used in the United States.

The Minox system includes enlargers, projectors, and copying apparatus, as well as devices for attaching to the camera, such as auxiliary viewfinders, supplementary filters, and flash apparatus. A few accessories not authorized by the factory are included because of their importance to the Minox user and collector. 35mm Minox cameras have been included, but the treatment is necessarily short in deference to the much longer history of the more collectable 9.5mm format cameras.

Advertising literature has been included for two reasons. Firstly, much of it is collectable for intrinsic value and sought after by advanced collectors. Secondly, this type of literature has additional value in helping to identify and date certain models and accessories.

While it is the author's hope that he has successfully identified all known Minox equipment, there will undoubtedly be some that has escaped his research. He would be grateful indeed to hear from his readers and critics on that score.

V.E.F. "Riga" Minox

The Riga Minox was the first production model made for sale. Because of material shortages, changes in industrial design, and the advent of World War II, the Riga has a wide range of variations. Chief characteristic of the Riga was its weight of just over 4 ounces (120g), as compared to

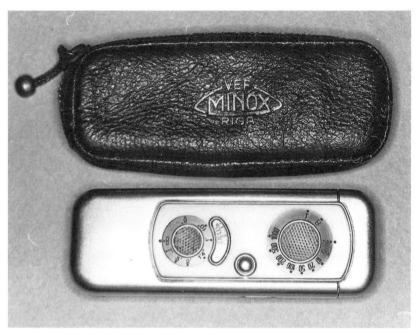

Riga Minox with zippered leather carrying case. Note by comparison that the 1'4" and 7' distance markings on this model became 1'6" and 6' respectively on later models.
Detail of the 2X marking for the yellow filter found on the Riga Minox.

the 2½ ounce (75g) postwar aluminium-bodied Models II and III. The stainless steel deep-drawn shell and internal brass body casting accounted for the Riga's weight. Another identifying element appearing on many Riga models was the "2X" impressed in the milled filter slide bar, and appearing over the filter when the latter was in place over the

Early Riga Minox, No.01781, showing 12-tooth winding claw on take-up side of cassette chamber. (Courtesy Japan Minox Club)

lens. This was the filter factor of the single yellow filter.

An internal variation was the number of screws visible on the inside of the camera: in general, two screws in the earlier serial numbers from approximately 01000 to 12000, and one screw in the serial number range between 12000 and 18000. Another internal variation was the number of teeth in the winding claw on the take-up side of the film cassette chamber. These teeth varied in number from twelve in the

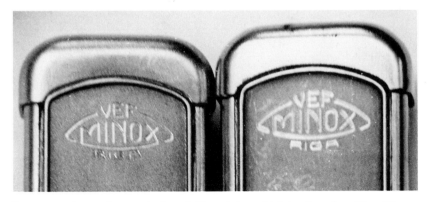

Two engraving variants - shallow (left) and deep (right) — found on Riga Minox cameras.

earlier models, serial numbers approximately 01150 to 03000, down to three from serial number about 02950. The three-tooth design became the standard for the post World War II models in the 9.5mm format. The tooth profile itself varied, and a "sharp tooth" and "flattened tooth" variety both exist.

Variations can be observed in the depth of the engraving on the back of the camera, as well as centered/off-centered versions of the lens name "Minostigmat". The most interesting aspect of Riga variations lies in the engravings on the back. One very early specimen, No.01104, shows the "VEF Riga" part of the logo centered approximately one-third the way down the body. A second variation, No.01201, shows the "VEF Riga" as part of the whole "VEF Minox Riga" logo at the top. In both these cases,

Two engraving variants of the lens designation seen when the Riga Minox is closed. Slanted and large (top); horizontal and small (bottom). Note also the transposition of the designation.

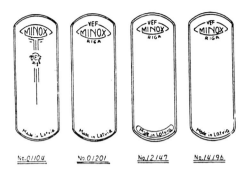
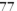

No.01104 No.01201 No.12147 No.14196

Above: Engraving variants on the backs of Riga Minox cameras.
Below: Russian Riga, No.07916, with "Made in Latvia" replaced by "Made in USSR" within a sunken area.

Above: Close-up of top back engraving on Russian Riga No.07916 showing effacement of the word "Riga".
Below: Side of Russian Riga No.07916 opened to show serial number. Note proximity of assembly locking screw to periphery of take-up side of cassette chamber, and also the 3-tooth winding claw.

the engraving "made in Latvia" appears at the bottom of the rear cover, without any other background or relief engraving.

Riga was occupied by Russia from 17th June 1940 to September 1941, and again from Spring 1944 onwards. From these two periods several Riga Minox cameras are known which were engraved, or re-engraved, to indicate USSR presence. Among these "Russian Rigas" are serial nos. 07916 and 12147. In the case of the former, the word "Riga" has been skillfully effaced under the Minox logo, and in both cases, the words "Made in USSR" appear at the lower portion of the rear cover. Records from the VEF material at the Latvian SSR Archives indicate that Russian engraving and re-engraving took place in the periods 1940-1941 and 1944-1945.

Some very early models below No.02000 have markings of "Pat. App." or "Patt. Appl", corresponding roughly to the time when some patent applications were in progress. Later models indicate erratic use of the word "Patented" on the body. Head-hooks, similar to small eyelets, appeared on some models in the 3000 to 5000 range, indicating some

Variant Russian Riga No.12147 (left) compared to Russian Riga No.07916. Note that the variant has no sunken area around the legend "Made in USSR" and that nothing appears under its Minox logo.

thought might have been given to a carrying chain before World War II, although the patent for the chain was not issued until 1950. One case is known of a hook installed by a camera repair man sometime after the war.

For those inclined to study the internal workings of the Riga, two distinguishing features are noticeable. The first is the presence of only

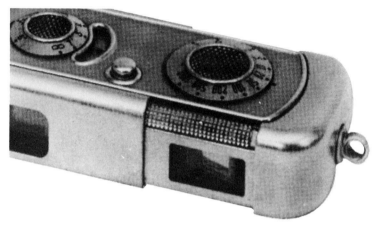

Above: Riga Minox detail showing eyelet at speed dial end of body.
Below: Internal view of a Riga Minox body next to a centimeter scale. Single shutter blade is at bottom. Note fly-weight, pawl, and single-armed sector timing gear in right half of body. (Courtesy Minox Club of Japan)

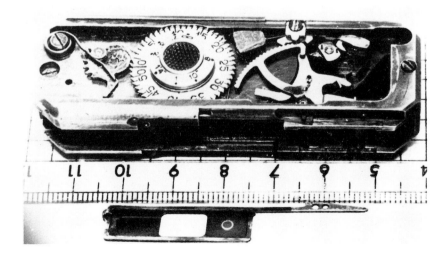

one shutter blade, and the second is the configuration of the gear which times the shutter. In the case of the Riga this central sector gear has one arm in the middle, instead of the two-arm or two-spoke design of the postwar models.

A final external feature is the round-shaped eyepiece of the viewfinder.

Above: Two Riga Minox cameras showing shutter condition visual warning. Upper shutter is ready for firing while lower shutter has been fired. Note that the presence of the little white ring indicated an uncocked shutter — just the opposite of post WWII Minox cameras.

Below: Detail of the round viewfinder (user's side) on the Riga Minox.

Minox II

The Riga became known retrospectively as the Minox I, when the first postwar Minox Model II was introduced in 1948. The most noticeable features of the Model II were the 5-element lens and two built-in filters. The postwar aluminium body became a standard feature in successive 9.5mm Minox cameras. The two filters were primarily orange and green, although earlier models in the 20000 to 25000 serial number range had a yellow and green pair, indicating use of earlier yellow filters salvaged from Riga, and use of some other Riga parts salvaged from storage in Switzerland during the war. The filters on the Model II did not retract automatically when the camera was closed, a feature added later in the Model III.

The 5-element lens design, Arthur Seibert's first postwar effort for the Minox, had the mechanical failing of trapping dirt and causing negative scratching. The rear lens element, or "film lens", was in closer contact with the film than in other models. Attempts to alleviate the attendant

Rear view of Minox No.25106. This is a Model II with the ported or hatched feature which is the small circular area with two dimples at the bottom center.

ills of this five element lens included furnishing a cork or chamois-covered cleaning stick with which to clean the rear element, and also introduction of a "port" or "hatch" design which opened to give more direct access to the lens system. This feature also appeared in a small number of Model II cameras of which No.25106 is an example. The feature appears mainly in the 25000-30000 serial number range. Problems with the 5-element lens design of the Model II became so severe that a new 4-element design, the famous "Complan", was introduced in 1951 on the Model III. Some variations occur with Model II and Model III lenses because of conversion of late Model II into Model III cameras.

The back engraving variations on the II and early III models present many challenges in identification. Specimens are extant with 5-element lenses and the back engraved as "IIII", with the additional complication of the word "Wetzlar" present on some. The "Wetzlar" also appears later, in an erratic pattern, through the Model III-s and Model B into the 750000 serial number range, where it occurs less frequently. Correspondence with the factory indicates early postwar attempts by Leitz to discourage the use by Minox GmbH of the word "Wetzlar", since the word and geographic location were claimed as being synonymous with prodcts of E. Leitz. Minox II production ceased in 1951, the cut-off serial numbers conceded by the factory to be in the range of 36500 to 39000.

Minox III

Minox III production began in Autumn 1951. The distinguishing features

Back engraving variants under Minox logo on Model III-s cameras. From left to right: No Marking, "Wetzlar", "III", and "Wetzlar" and "III".

of the III were the 4-element Complan lens, designed by Seibert, and automatic filter retraction when the camera was closed. In the Complan design the rear element was moved into a recess, eliminating most of the film scratching problems. Additional design changes in the III provided a more brilliant viewfinder image with refined parallax correction. Serial numbers for factory-original Model III cameras begin at 31275, and run to approximately 58500 in 1954, when the III-s was introduced. Engraving variations on the Model III include the presence or absence

Minox Model III dummy issued to dealers circa 1951. These served as window and show-case pieces when there were shortages of working cameras. The hole drilled in the back, just above the serial number, was a reminder to both the dealer and customer that the camera had no internal mechanism.

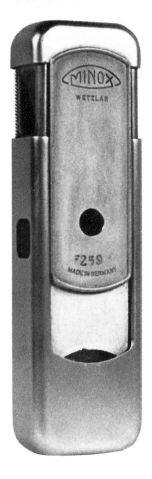

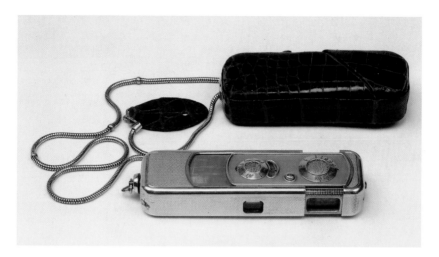

Gold Minox III-s. Note diamond-mesh pattern on each end of body.
(Courtesy Don Thayer)

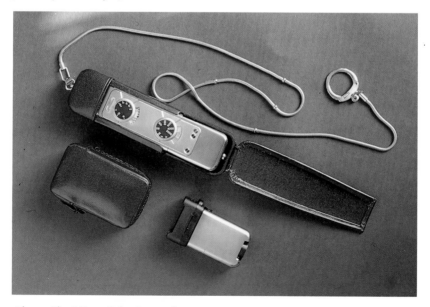

Above: The Minox Selection outfit.
(Courtesy Hove Camera Company)

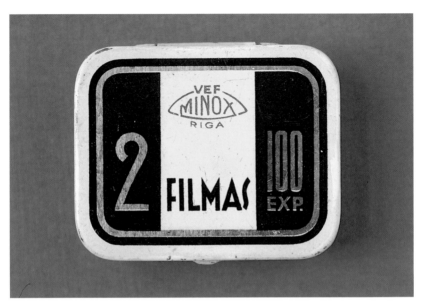

Top and underside of Riga film tin. This is the actual tin which contains the historic negatives of the House of Commons in session in May 1940, taken by the late Lord Brabazon, and now in the Royal Air Force Museum, London. (see Chapter 8) (Courtesy RAF Museum)

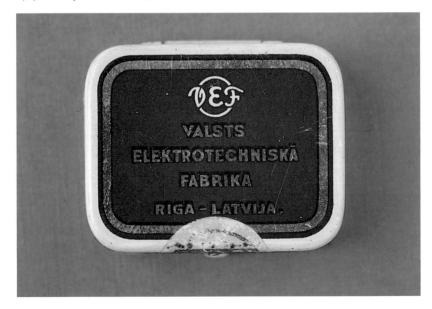

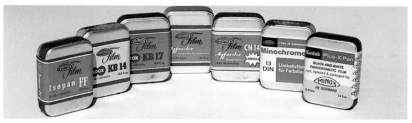

Film packaging in the era of the Minox B, the late 1950's.
(Courtesy Minox GmbH)

A Minox B with contemporary film packaging.
(Courtesy Minox GmbH)

Minox film packaging in the 1970's.

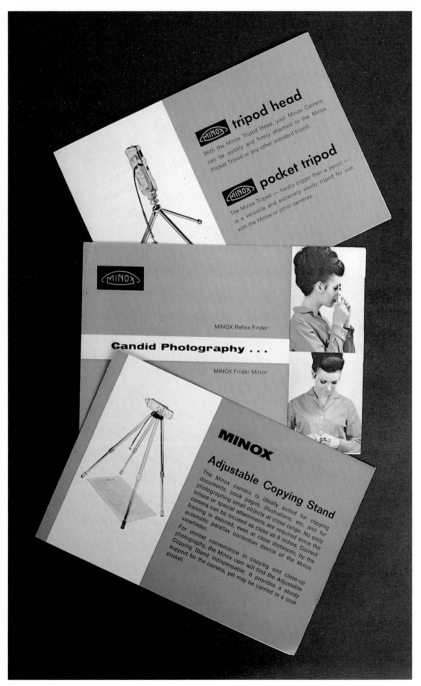

1960's Minox brochures.

of "III" as well as that of "Wetzlar". Standard filters on the III were orange and green. While the original Riga had a white ring on a dark shutter blade to indicate when the shutter was in the cocked or uncocked position, a variety of white dots, white circles, black dots, and black circles appeared on postwar models to indicate when the shutter was cocked!

Minox III-s

The III-s, introduced in 1954, was the III with flash synchronization. The PC-type flash socket can be seen at the logo end of the camera. The III-s also introduced the era of the black "Private Eye" and "gold" body variants. Serial numbers for the III-s begin near 60000. Starting around 143000 a green and neutral-density filter combination replaced the earlier green and orange. The III-s enjoyed a 15-year production life until serial number 147494 in 1969, overlapping in production with its extremely popular successor; Model B, introduced in 1958. Several

Black Private Eye Model III-s. (Courtesy Don Thayer)

Shutter blades and springs of a Minox III-s, shown next to an American penny. Photo approximately 1 ½-times actual size.

common engraving variations of the III-s include "Wetzlar" with and without "III" or "III-s" and no engraving other than the familiar Minox logo itself and the usual "Made in Germany".

The III-s ushered in one of the most prosperous and productive periods in postwar factory history. After the Model B was introduced in 1958, the Model III and III-s were referred to in Europe as the Model A.

Minox B

First made in 1958, starting with serial number 600001, the Model B was the first 9.5mm Minox to incorporate a built-in light meter. The meter was the selenium cell type and could be cross-coupled to the ASA film speed by setting a gearing relationship on the body of the camera. Production figures indicate that the Model B was the most popular of all 9.5mm models, running to serial number 984328 in its final year, 1972. The Model B had the neutral-density/green filter combination of the later III-s, but it went back to non-automatic filter retraction, occasionally causing a seasoned Model III-s user some consternation if he did not want a filter for his next Model B shot. The ASA setting feature of the Model B allowed the user to also remind himself of film speed. When the neutral density filter was in place, the meter reading was automatically compensated with a switch to account for the ND filter factor of approximately 10X. Variations of the Model B included both black and a very limited number of gold bodies, together with various back engraving schemes involving "Wetzlar" and "B" markings. In a move to diversify and effect production economies, some Model B cameras were assembled in Italy, and are engraved with the legend "FI" which stood for "Fabbricata in Italia" (made in Italy). Late runs of the Model B included a variation of the louvred window over the photocell. Serial numbers for this latter variation appear to be concentrated from No.861500 to the end of Model B production.

Later chrome Model B with honeycomb lattice to meter cell. (Courtesy Don Thayer)

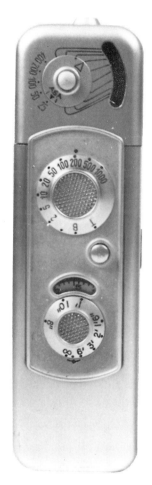

Model B Minox camera, front and rear views.

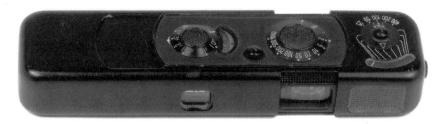

Black Model B with square lattice window to meter cell. (Courtesy Don Thayer)

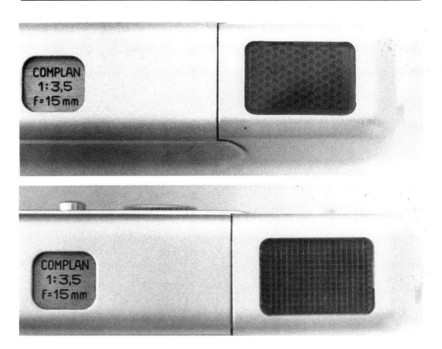

Variants in photocell windows on the Model B. On top is the later model with honeycomb lattice window. On bottom is the earlier model with square lattice.

Minox C

Model C production began in 1969, with serial number 2300101. This was a major redesign, incorporating full automation, and using an electromagnetically-timed shutter coupled to a CdS photoresistor. The feature immediately apparent in the Model C is the presence of *three* dials for the settings. The Model C was the first in the 9.5mm series to have a film advance, shutter release interlock. The power source for the shutter and photo-cell circuitry was a 5.6 volt mercury battery (PX-27 or equivalent).

Another first on the Model C was discontinuance of the curvilinear film gate in favour of a flat film plane. This radical change was made possible with newer optical glasses and computer-aided lens design. However, legend dies hard and some very early Model C cameras in the 2303600 to 2331000 serial number range carry the "Complan" lens name, whereas later ones have "Minox" as the lens designation.

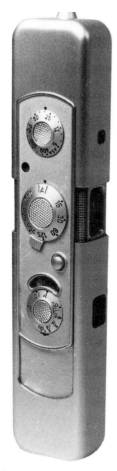

Left: Model C Minox, front view.
Right: Model C, back view. This is serial No.2355301 and displays the engraving variant "FI" which stands for "Fabbricata in Italia" (Made in Italy).

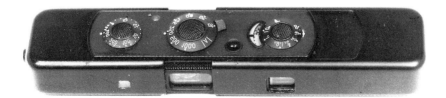

Black Model C. (Courtesy Don Thayer)

Additional variations were black bodies, spasmodic engraving of the letter "C" on the back (mostly in early runs) and a few uncommon "FI" (Made in Italy) engraved backs.

The exposure counter of the Model C indicated the number of exposures remaining, instead of the number of exposures taken (which was common with most III's and B's). The final Model C to come off the line in 1976 was No.2469964.

Minox BL

The Model BL was a very short-run version spanning the production period from 1972-1973. Some Model BL production took place after the Model C had been introduced, and just before the cessation of Model B production. The chief visual feature of the BL was the redesigned meter readout with the segmented series of lines and single pointer of the Model B replaced by a needle with red, two-pronged shutter-coupled pointer. When the meter needle was centered in the pointer, the shutter was set for proper speed. An ASA dial on the back of the body adjusted the meter for the speed of the film being used. Only the neutral density filter was fitted and the filter slide bar could also be set in a battery-test

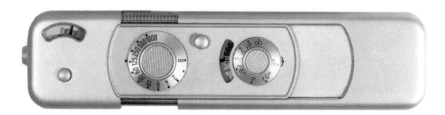

Minox Model BL, front and rear views. Compare the meter design with the Model B, noting the forked indicator surrounding the meter needle of the BL and the lack of any scale under the indicator.

mode. The majority of lenses were marked "Minox" and the most common back engraving was simply "BL". Black body variations exist.

Minox LX

The Minox LX introduced in 1978 and still in production is the top of the line in 9.5mm Minox design, and is distinguished partly by the ergonomically designed, bar-shaped shutter release curved to fit the finger. This release is at the end of the body nearest the focusing dial. Three LED's (Light Emitting Diodes) are at the end of the body nearest the shutter speed dial. In addition, the two setting dials are milled around their peripheries, breaking previous 9.5mm design tradition of center-dimpled setting dials. Another identification point is that the top shutter speed on the LX is 2000 ($\frac{1}{2000}$ second). Two small engraved dots appear

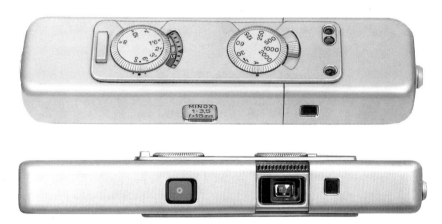

Minox Chrome LX. Note the milled peripheries of the two setting dials and the rectangular shutter release bar to the left of the distance setting dial. Lower picture: in the open position. (Courtesy Minox GmbH)

Black Minox LX. (Courtesy Don Thayer)

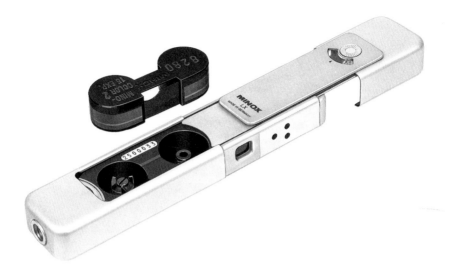

Model LX, open, showing fitting of cassette and three-tooth wind claw.
(Courtesy Minox GmbH)

on the body, one on each side of the focusing point dot, and concentric with the periphery of the focusing dial. The single built-in neutral density filter has a factor of 4. Variations include black, gold, and promotional-logo bodies, one of which is a special black-bodied Volkswagon edition complete with a small white VW symbol.

A brochure put out by E. Leitz with the theme that the "Minox was not just for beautiful spies..." featured a hand-tooled leather, wallet-type carrying case which held spare film, credit cards and cube flash adapter.

Minox EC

The EC, first manufactured in 1981 and still in current production, breaks 9.5mm tradition again in many ways. The lens is a f/5.6 fixed-focus design. The shutter release button is made of colored plastic, and the ASA setting is a helix-shaped control. Opposite the helix is a three-position switch for flash, automatic exposure for available lighting, and battery check. A serrated disc on the underside of the body is used to set the film counter. One very distinctive feature is that the film chamber is opened in a way that frees the back cover from the body. Parallax markings on the viewfinder are absent, due to minimum parallax at the three-foot nearest-fixed-focus point.

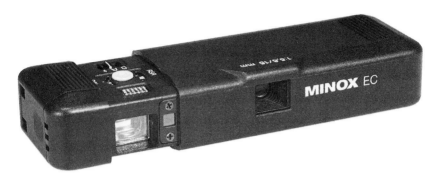

Minox EC with f/5.6 fixed-focus lens. The helix-shaped ASA setting control can be seen just over the top of the viewfinder at the left end of the body.

The normal plastic body color is black. There is a brown variation, and a very limited edition of white bodies. A show-case at the factory contains experimental bodies in over 20 different colors.

"Gold" Minox Cameras

Because of extreme difficulties in electroplating gold onto aluminium shells of Model III-s and B cameras, and the earlier separate matching exposure meters, the metals used to make "gold" Models were of a special composition. More importantly from an identification point of view, on the gold Model III-s and Model B cameras, and matching meters, the shell ends were milled or embossed in a diamond-shaped pattern. Occasionally, what appears to be a "gold" Minox surfaces, and is offered

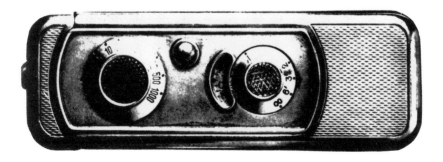

Enlarged detail of Gold Minox Model III-s showing engraved, diamond-mesh pattern on each end of body face.

Side view of Gold Minox III-s showing the characteristic diamond-mesh pattern.

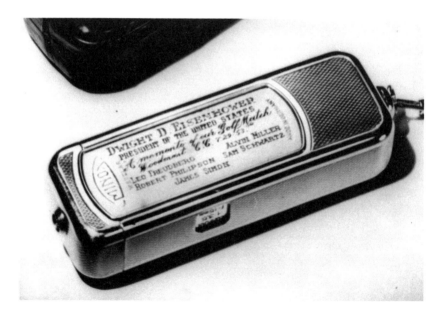

Gold Minox III-s presented to U.S. President Dwight Eisenhower in 1953. The presentation was made as a consequence of the friendship between Eisenhower and Sam Schartz, a well-known photographic dealer in the Washington D.C. area.

for sale to an unsuspecting buyer. This type of camera more often than not turns out to be an ordinary aluminium shell Minox which has been "gold-plated" by someone with advanced skills in electroplating and time on their hands. The author has seen a few of the milled, or embossed, shells that were used for trophies converted into working Model III-s cameras, but upon close inspection the holes that were originally used for mounting the shells in the trophy were detectable.

Other than the black Private Eye version of the Models III-s, B, BL, C, and LX, and the gold Models III-s, B, and LX, no other colors were authorized in the 9.5mm series, according to factory records. The author has seen home-made specimens of anodized bodies in copper-color, red, and blue.

One gold Model III-s was presented to President Eisenhower in 1953, and a gold Model B was presented to HRH Prince Philip, Duke of Edinburgh in 1965.

The Minox Selection was a 24-carat gold-plated LX issued as a limited edition of 999 to mark the 50th anniversary of the first ever Minox. The set included a gold-plated chain and flash cube unit, with leather cases, all in a mahogany presentation box.

The back engraving legend on a Gold Minox B presented to H.R.H. Prince Philip.

9.5mm Minox Film Packaging

Early Minox film of the Riga era was spooled in brass cassettes, and sold in small tins, similar to those used for aspirin. The VEF logo appeared on each side of the tins, one side indicating two 50-exposure loads inside. The only two films packaged under VEF sponsorship were 10/10 Din (ASA 8) and 17/10 Din (ASA 40) panchromatic emulsions.

Postwar advertisements circa 1949, offered color film in the range of 32 ASA, much of it privately spooled. From 1952 black-and-white in ASA 32, 64 and 125 was offered by Minox. By 1954, 30-exposure color film in Anscocolor and Anscochrome was being offered, and the black-and-white film line had expanded covering ASA 5 to ASA 200. Color coding of labels in 1954 for the American trade was as follows: ASA 5 white; ASA 25 yellow; ASA 64 blue; ASA 125 red; ASA 200 brown. The ASA 200 was the "old" Kodak Tri-X. In 1955 new packaging was introduced with the films in two-pieced hinged cans, a mailing bag, and a Minox product line folder — all packed inside a small box measuring 2x2¼x1in. A promotional item; the "Quartet Film Pack" was offered in the 1950's. The black-and-white film boxes were two-color printed and the color film was three-color printed on the outside.

Front and back (right) views of VEF film tin which held two 50-exposure loads.

Early brass Riga cassette (left); modern plastic cassette (right).

1950's film pack (left); 1950's tin which held two cassettes (center); late 1960's-1970's film pack (right).

The slowest film had became ASA 12 (usually some form of orthochromatic film for copy work) in a green and yellow box; ASA 25 was yellow and white; ASA 50/64 was blue and white; ASA 100 red and white; and the ASA 200 film had a black and bronze color combination. The boxes containing color film were made up in turquoise, magenta, and white with opposing colors to distinguish color-print from color-transparency films. Film speed was marked on the front and side of the boxes. In general, right from the Riga era, black-and-white films had been spooled in 50-exposure loads but these were discontinued by the factory around 1967. The 36-exposure black-and-white load had been phased into the line in the early 1960's, in response to many inquiries asking for a "weekend load", since most people took a long time to shoot 50 exposures. Newer color emulsions appeared as Agfa CN-14 print and CT-18 chrome were introduced in 1962. The color loads were marketed in various lengths including 36, 30 and 15 exposures.

In 1972 Agfa black-and-white appeared in ASA 25 (both ortho and

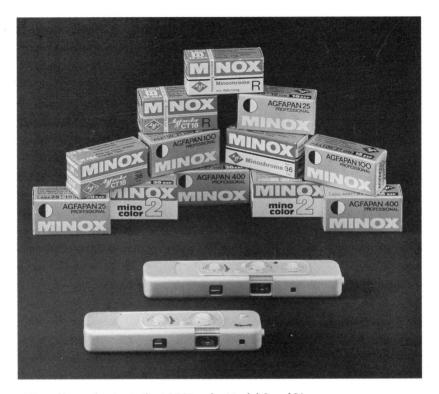

Minox film packaging in the 1970's — the Model C and BL era.

pan), ASA 50, 100 and 400 speeds. Color film labelled as Minocolor and Minochrome has been offered in 15- and 36-exposure loads since the 1970's, and the original film suppliers have included both Agfa and Fuji up to the present time. Factory film loading has traditionally been done by blind people who exhibit unusual skills in the work.

After many mishaps, the plastic film cassette was introduced in the late 1960's. Bootleg and reloaded cassettes caused no end of headaches for Minox users, with contamination from plasticizer vapor and difficulties with mechanical binding. The plastic Minox factory cassette is a deceptively simple looking device, but it is made from ten separate parts, all moulded to precision tolerances. A poor plastic formulation, undetected damage to the moulding machinery, and dozens of other subtle mishaps can produce a useless cassette, and Minox quality control in cassette manufacture and loading are two of the tightest inspection areas in the plant.

ry Viewfinders

sometimes confusing range of auxiliary viewfinders were
ost early models of 9.5mm Minox cameras. The two basic
the right-angle viewfinder, which permitted "sneak"
to one side while the photographer appeared to be looking
d, and the reflex type, which allowed waist-level viewing.
ersions of the right angle type could only be used on Models
nd could only be used to photograph to the right. A later
itted photographing from either side. The reflex type did
ough the camera's lens, and some adjustment for parallax
de when using this type for close-ups. The reflex types were
m the line in the late 1960's. Specific models are listed

II-s

Nos: 63;6200;173-063
Nos: 66;6201;173-066
Nos: 62;6202;173-062
Nos: 65;6203;173-065

ent universal right-and-left right angle plastic viewfinders
esignated as Leitz No.97308. A universal right angle auxiliary

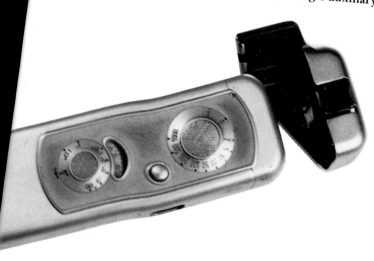

pe auxiliary viewfinder for Model III-s Minox, shown at one end
dy, before attachment.

Film Slitters: For manufacturing economies, 16mm- and 35mm-wide films have traditionally been slit from much wider rolls. The Minox 9.5mm factory film is derived this way. Over the years, many 9.5mm Minox users have sought ways of slitting their own films and avail

Specially designed slitters for producing 9.5mm and 16mm film. Left to right: three 9.5mm from 35mm unperforated; two 9.5mm from 35mm; and 16mm from 35mm. The action is really one of shearing rather than slitting. Tip of pencil at left points to concave roller face on upper roller.

Detail of the three 9.5mm from 35mm slitter. Note concavity of roller sections which minimizes scratching. Feed end of the slitter (right) complete with plexiglas tray which is undercut to further minimize scratching.

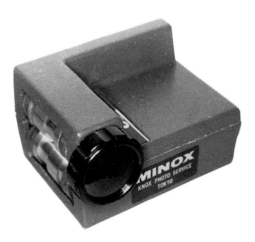

Another slitter design which incorporates a driving knob to eliminate pull-through by hand. (Courtesy Richard Conrad and Japan Minox Club)

themselves of emulsions that were not packaged by the factory. The simplest scheme has been to use two razor blades, the correct distance apart for the desired film width, in a rigid mounting. Much more refined film slitters have been constructed by advanced workers.

The 9.5mm Minox user is cautioned against slitting his own film, except on an experimental basis, and always with the express caution that a 9.5mm Minox can be seriously jammed if the slit film is too wide or if it has irregular edges. Minox has never manufactured film slitters for use by the individual camera owner, preferring instead to control all steps of the film slitting/packaging operations. This is the only way that high-quality control of the entire Minox system can be maintained for users world-wide.

The slitters illustrated here are shown for information only and were designed independently of the Minox factory. It is deceptively simple to construct a makeshift slitter, only to discover that it has produced countless film scratches, or made an expensive camera repair necessary.

Minox 9.5mm A

Minox Accessory N

In addition to the descriptive nan
attachment, enlarging easel, etc
numbers have been used over th
or distributor numbering schemes.

To reinforce identification wh
container that is numbered, appro
the following descriptions. The e
U.S.A. usually took the form of two
90 series which were numbers agre
Sr. and the factory in Germany. And
numbers were used by Kling Photo
era. When Leitz assumed Minox dist
1981, the numbers assigned were
series. Following Leitz came the Hass
when designations were mostly by n
EC, and some of the 35mm models. I
in a roundabout return to the early 1
and became the sole importer and
United States. The current series of
10000 and 20000 ranges, with a few 9

An example of the various number
would be the postwar enlarger with s
in the *Minox Memo* as No.80, in the
as No.6770 and 176-080, in the Leitz
1988 Thayer listings as No.25402.

The numbering schemes discussed h
and other numbering schemes were use

Two major categories of directly-att
were the auxiliary viewfinders and flash

Auxilia

A variety and
offered for m
designs were
photography
straight ahea
Early metal v
III-s and B, a
version perm
not view thr
had to be ma
dropped fro
below:

Right Angle
Reflex III-s
Right Angle
Reflex B

More re
have been

Right-ang
of camera

Right-angle type auxiliary viewfinder, shown attached to Model III-s body. Note reflection of rear finder window in mirror of auxiliary finder.

Right-angle mirror attachment for Model B. (Courtesy Don Thayer)

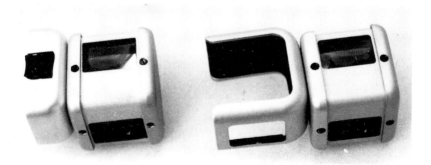

Auxiliary reflex viewfinders for III-s (left) and B (right).

Auxiliary reflex viewfinder attached to Model B. The reflex type finder for the III-s camera had a shorter mounting base due to the absence of the exposure meter port. Because the reflex finder was mounted to one side of the camera's actual viewfinder there could have been parallax errors at very close distances when using this type of auxiliary finder.

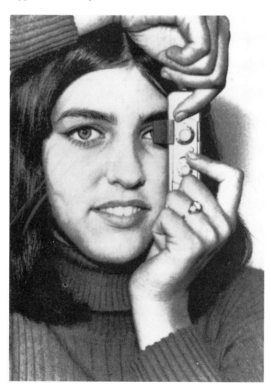

The universal right-angle auxiliary viewfinder in left-hand viewing use.

Late model universal right-angle finder: Leitz No.97308.

finder was also offered for Models B & C under the earlier designation No.64;173-064. Both types are no longer available.

Flash

The earliest of the 9.5mm flash units were the all-electronic fan-fold reflector strobe unit and the B-C miniature flash using M-type flashbulbs. These were followed by AG-1 "peanut" flash units, a variety of cube flash units, and then the ME-1 electronic strobe in 1967, and the ME-2 in 1972. Specific descriptions and catalog numbers are given below.

Early Electronic Flash: This Minox Electronic Flash was introduced in 1956. Its distinguishing feature was the binocular-shaped leather carrying case which held the power supply, the coiled cord to the strobe unit, and the strobe unit head itself with the fan reflector. A battery powered version (No.6510) using an Eveready No.491 battery or equivalent, and an a.c. supply unit (No.6521) were both offered. The strobe tube itself looked a little like the cap on a toothpaste tube. For greater "light throw" and use with color film, a high-efficiency polished reflector (No.6522) was available as an accessory.

Early B-C Flash: Following the introduction of the Minox III-s flash-synchronized camera in 1954, Don Thayer Sr. had an M-type flash bulb unit designed in the U.S.A., with Minox factory approval. This unit slipped onto the camera end carrying the synchronizer (PC) terminal, and could be used with either a fanfold reflector, or the same No.6522 high-efficiency polished unit that was used with the No.6510 electronic strobe. These early M-type bulb units were designated as No.6541, and

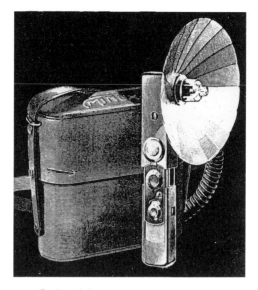

Early Minox electronic flash with battery power pack in binocular-shaped leather case.

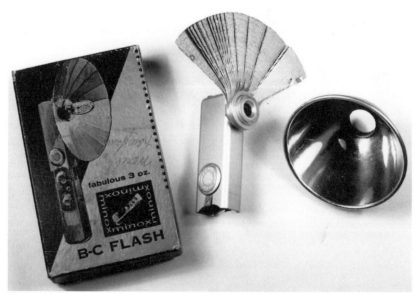

B-C flash for M2 flashbulbs with auxiliary polished chrome reflector (right) for "high throw". This flash was designed by Don O. Thayer Sr. and built in the U.S. with the approval of Minox GmbH, Germany.

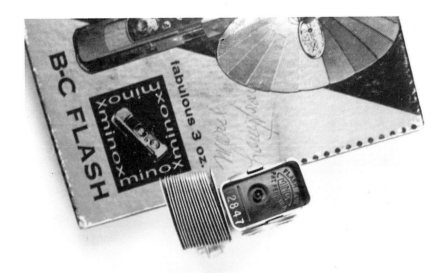

Bottom view of M2 B-C flash leaning up against box and showing Minox logo inside next to P-C terminal.

used mercury batteries when first introduced. The mercury batteries (sold as Minox item No.6542) were prone to leakage and malfunction, and were soon replaced with Eveready No.504 or equivalent carbon-zinc 15-volt batteries (sold as Minox No.6546).

AG-type bulb flash units: With the introduction of the AG "Jelly Bean" flash bulb in 1958, several Minox B-C flash units were offered. These were chiefly characterized by a slide-up type trough-like reflector. The numbers are listed below.

AG-1 type B-C flash unit mounted on Model B camera. This unit was for Models III-s, B and C, and was available in black for Private Eye Model B. It was lined underneath with leatherette to prevent scratching of the camera body, another small detail indicative of Minox workmanship.

Universal model U Minox flash for cameras having standard mounting shoe and P-C terminals.

this new minox adapter shoe

gives owners of every fine camera the world-acclaimed advantages of Minox dependability, compactness and portability for all flash requirements.

Camera dealers everywhere will demonstrate how this fabulous little accessory permits the Minox Electronic Flash and/or B-C Flash to be attached to any camera having a standard accessory shoe or flash bracket merely by the addition of a standard polarized cable. For the first time in photographic history, a high efficiency electronic flash can be easily carried over the shoulder, in a man's pocket, or in a lady's purse, without cumbersome flash-heads . . . the B-C Flash, of course, fits in the pocket like a pack of cigarettes.

Minox adapter shoe which permitted the attachment of the Minox electronic flash (binocular case model) or M2 B-C flash to any camera having a standard accessory shoe (P-C to female polarized outlet).

For Model B Nos.31;6543;172-031 chrome
For Model III-s Nos.32;6544;172-032 chrome

The suffix "BL" in the catalog number (not to be confused with camera Model BL!) sometimes denoted the unit was in a black finish for use with the "Private Eye" series camera. Corresponding numbers in the black Kling series were 172-731 for the black Model B camera, and 172-732 for the black Model III-s.

A so-called universal model, the Model U B-C flash, was added to the line as No.6545. This unit could be mounted on any 35mm or similar size camera having an accessory shoe. The type U unit had an integral cord with P-C terminal.

Flash Adapter Units: A unit called an adapter shoe (designated No.6591) was offered around 1958 to permit use of the early electronic and early B-C Minox flash units with any camera having a standard accessory shoe or flash bracket. The adapter was made of moulded nylon, and consisted of a male P-C terminal connected to a standard polarized female outlet.

With the introduction of the Model B camera in 1958, many owners of the No.6541 early B-C flash, who had purchased it for a III-s camera, were offered a "flash lock plate" were they to trade up to or purchase a Model B camera. The flash lock plate had openings for the catch tongue of the flash unit, and also for the meter button of the Model B. The flash

Accessory flash lock plate for adapting Model B cameras for use with M2 B-C flash units. This accessory, like the M2 B-C unit, was made in the U.S. to Minox GmbH standards and designed by Don O. Thayer Sr.

lock plate unit was designed by Don. O. Thayer Sr. and made in the United States. Fittingly enough, it bore the Minox logo and the factory's approval – one of the very few accessories not made in Germany.

Two flash adapters sold later in the Leitz-Minox era of distribution bore designations of "Hot Flash Shoe" (No.97432) and "Flash Adapter, Minox Flashgun to other cameras" (No.97434).

Cube flash Units: A cube flash unit designated as the "B4" was introduced in 1958, primarily for the Model B camera. Later in 1970, a "C4" cube flash unit was added for use with all 9.5mm Minox cameras that had synchronization for flash. The C4 unit was also designated as No.43 in chrome and No.44 in black. Cube flashers had to be repositioned by hand between each shot, and were not too popular with either dealers or users. As most flash bulb units, cube or bulb, were designed to synchronize with Minox cameras up to $1/20$ second, their use was limited mainly to portrait and still situations.

 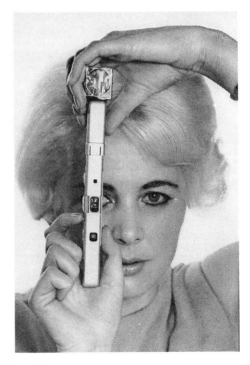

Left: B4 flashcube unit for Models B and C cameras.
Right: C4 flashcube unit in use on a Model C. Introduced in 1970 the C4 could be used on previous model cameras having a P-C synchronization terminal.

ME-1 Strobe: The ME-1 strobe, also known as the Minox Heliotron (No.172-045) was introduced in Fall 1967, and represented a major step forward from the first 24 ounce electronic flash in the binocular-type case. The ME-1 weighed 15 ounces and the power-pack/control unit was shirt-pocket size. The chief identifying feature on the control unit was the calculator dial/light output selector switch, with ribbed handle, on top. A 40in. cord connected the power pack to the strobe head which

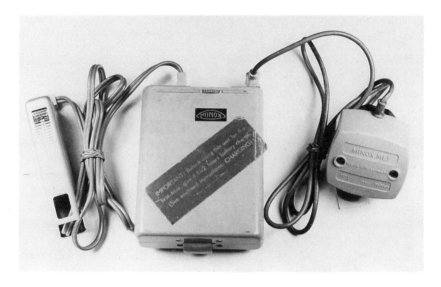

Above: Minox ME-1 flash outfit. From left to right: Flashgun head; powerpack/main body, A-C recharger unit.

Below: Close-up view of control settings on ME-1 power pack control unit.

ME-1 outfit used with wrist strap on power unit.

fitted on the camera. The power pack could also be worn with a wriststrap or on the belt. The ME-1 was designed for use with the Model B and C cameras. A separate charger cord unit (No.46) enabled overnight charging of the ME-1's nickel-cadmium battery from 120/240 volt a.c. sources.

Marketed at a time when nickel-cadmium battery technology was undergoing many changes, the ME-1 was further plagued by power-pack distance-setting procedures that were somewhat confusing and seemingly complex, except to a small number of very dedicated Minox users. The unit was withdrawn from sale in 1972, and replaced with the ME-2.

ME-2 Strobe: This unit (No.053) was a self-contained nickel-cadmium design that weighed 9 ounces, and plugged directly to the Minox Model B and C cameras. The ME-2 operated from a charged battery or a 120 volt a.c. power source. Synchronization speed settings on the camera dial were set at $1/100$ for the Model B camera, or $1/125$ for the Model C camera. The camera actually locked into a recessed opening within the body of the ME-2, and the entire ME-2 only measured 2½x4¼x1in. An accessory shoe (No.54) allowed the ME-2 to be used in the hot shoe of other

cameras. The standard finish was black with chrome trim. One very interesting and rare variation is a ME-2 in a transparent case which shows the inner electronic components and was made for sales demonstrations.

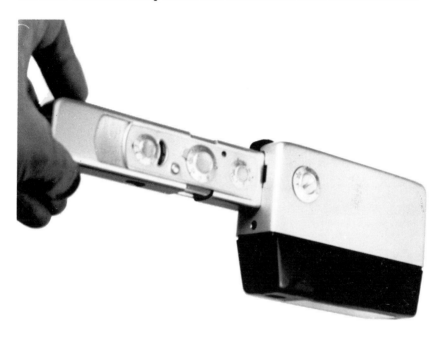

Minox ME-2 head mounted on Model C Minox.

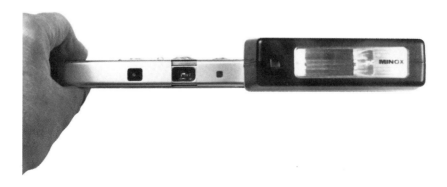

Minox ME-2 flash head with adapter for use with cameras having conventional flash shoe.

Filters

Up to the mid-1960's, filters were an integral part of the 9.5mm Minox design. The early Riga had a yellow filter, the Model II and III series had yellow and green or orange and green, and the III-s and B had green and neutral-density filters. Additional snap on type supplementary black-and-white and color correction filters were added to the line in the early 1960's. These sets are detailed below.

Minox III-s: (No.67A)(767)(No.173-767) Black-and-white: Yellow 2X, ND Gray 10X, Ultra-Violet.

Minox B: (No.67B)(067)(173-067) Black-and-white: Yellow 2X, Orange 3X, Blue 1.5X.

Minox III-s and B: (No.68)(No.173-068) Color correction: Skylight (Pink) – also called R3, Medium Skylight (Red) – also called R6, Flash Conversion – Blue.

These snap-on filters for the III-s and B were just large enough to fit on the lens opening and consisted of a U-shaped holder with threaded hole, plus three screw-in filters. They were furnished in a plastic holder to minimize dust pick-up and risk of loss.

Minox C: The snap-on filter design required covering both the lens and the photocell with the same filter. The shape of the snap-on filter on the C was an elongated rectangle with openings for the lens, CdS cell, and viewfinder port. The set (No.69) consisted of: Pink – also called R3, Red – also called R6, Green.

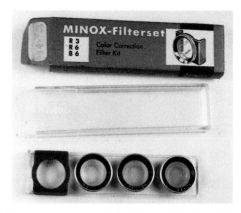

Set of R3, R6, B6 snap-on filters for Model B. A label on the open end of the box carries the number 173-068, further reinforcing the identification as a color correction set.

Clamp-on filter for Model C. These filters came in sets of 3 in a plastic box for protection, similar to the B sets.

A later version of the C filter kit under Leitz U.S. distribution was No.97311 containing green, skylight, and No.81EF color-correction filters.

LX and EC Accessories

Both LX and EC cameras are still in production at the time of writing, and the limited number of accessories specific to these two models are grouped here.

Flash Attachments: A flash cube unit, the FL 4, was made initially for the LX and was also suitable for use with Model B and C cameras. It was cataloged as No.97258 chrome, and No.97259 black, under Leitz distribution. The current Thayer catalog number is 22084. A hot flash shoe adapter for using other flash units with the LX is Thayer No.22202.

A flash cube adapter, called the FE 4, is made for use with the EC, and is cataloged as Thayer No.22410.

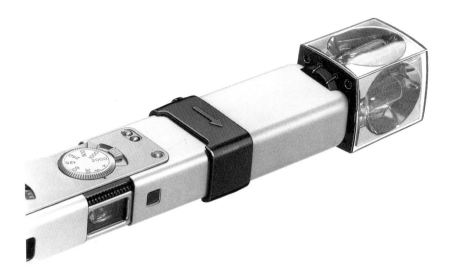

FL4 Flash cube unit for Model LX. (Courtesy Minox GmbH)

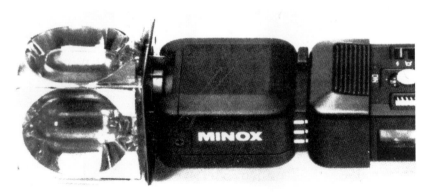

FE4 Flashcube adapter unit for Model EC.

The Minox 8x11 Flash was launched in 1990 for the EC. With a special adapter, it can be used with the LX and earlier synchronised 8x11 Minox cameras. A combi case completes the equipment: it holds the EC camera and flash, or, for other Minox cameras, the flashunit, adapter and a film.

Other LX and EC Accessories: So-called LX "Wallet Pak" cases in burgundy and black leather were offered as part of the LX Leitz marketing program. These were cataloged as separate items under Leitz No.97212, and as a "Private Eye" package with black LX, matching flash,

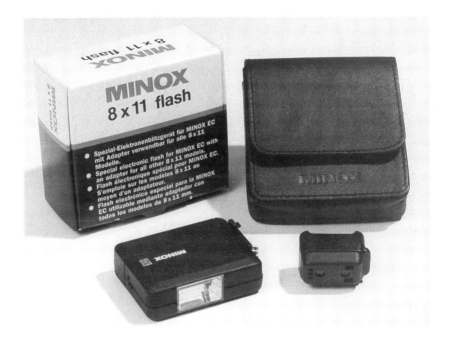

8x11 Flash Unit, with adapter, for LX and earlier 8x11 cameras, and combi case. (Courtesy Minox GmbH)

and "Wallet Pak" under No.97192.

A special screw-in fitting for using a chain with the LX was cataloged as Leitz No.97262, and is now Thayer No.18160.

Both a neck strap, No.18166, and a replacement chain, No.181659, are offered for the EC in Thayer sales lists.

Exposure Meters

The earliest Minox exposure meter was the Riga extinction type meter, which was approximately the size of today's credit card and about ¼ inch thick. Most of these meters are found in non-functioning condition due to deterioration and breakage of the sliding calculator bands. Riga exposure meters are readily distinguishable by their graphic symbols, and resemble in general appearance the Leudi meters so popular in the late 1930's early 1940's period.

In 1953, Minox introduced a separate hand-held selenium cell meter, manufactured by Gossen. The design was a collaborative effort between

Close-ups of VEF Riga Minox exposure meter. Note delineation of lighting condition by graphics just above shutter speed band in lower photo, and overall resemblance of meter to the more familiar "Leudi".

Piemērs elektriskai gaismai.

Objektīva relatīvā gaismas spēja 1:3,5, filma — panchromatiska ¹⁸/₁₀⁰ DIN, spuldze — 200 W, spuldzes attālums no objēkta — 1,5 m, dod 1 sek; vidējam objektam, piem. portreju uzņēmumiem.

Ja lieto grozas ap gaišu objektu, piem. reprodukcijām, sevišķi ap techniskiem zīmējumiem jeb rakstiem, tad ir jāgaismo ar ¹/₅ sek.

Visi šis tabeles dati ir derīgi panchromatiskām filmām.

Ortochromatiskai filmai pie elektriskās gaismas nepieciešams apmēram dubults izgaismošanas laiks. Dienas laikā pie zema saules stāvokļa ir jāgaismo mazliet bagātigāki.

Page from instruction book for VEF extinction-type exposure meter (circa 1939).

E. Pfaffenberger of Gossen and Walter Zapp. The meter measured 1⅛x2¹/₁₆x¾in., (30x52x20mm) and used the combination of the rotatable barrel and calculator table to produce the necessary shutter speed setting for a given film speed. The meter also had a built-in viewfinder.

Early versions were engraved "Minosix" and later versions bore just the Minox logo. The most common alumium-cased meter was cataloged as No.6110. A gold finish variation, in alligator case, was offered as No.6111. This gold meter had the same diamond-checkered pattern appearing on gold Model III-s and B cameras (See section on Gold Minox

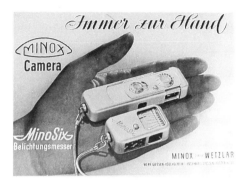

An advertisement (circa 1953) for the Minosix version of the separate Minox exposure meter.

Left: Front view of the separate Minox exposure meter with selenium photocell. This is the variant marked "Minox", which is more common than the "Minosix".

Right: Back view of the separate Minox exposure meter. Wheel on upper right revolves to adjust light and shutter speed relationship to meter needle readings.

Cameras). A less common variation was the black "Private Eye" model cataloged as No.6112.

Separate meters were discontinued around 1961, three years after the advent of the very popular Model B, which had its own built-in meter.

Cases and Chains

The standard leather case for the Model III-s and B was in brown morocco leather (No.6400) when each of these models was introduced. The initial catalog listings show that black, red, and green could be specially ordered at no extra cost up to 1958. From 1958 to 1964, brown, black, and red, became stock items.

Factory-issued cases for the gold III-s and gold B were in alligator leather, as were the matching cases for the separate gold meters. Standard cases for the "Private Eye" black Models III-s and B were in black leather. Both pocket and belt cases were offered for Models III-s, B, BL, and C, and ever-ready cases are listed in the literature for Models B, BL, C and LX. Because so many small Minox accessories, such as the AG-1 flash unit, came with a case which look very similar to some camera cases, the reader is cautioned to look for the reinforcing rings at the end of any camera case. These were designed for use with a chain. The author has seen home-made holes cut into cases that were not designed for use

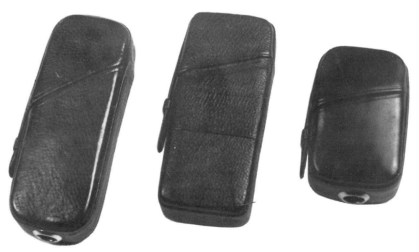

Miscellaneous cases for Minox 9.5mm cameras and accessories. From left to right: Minox III/III-s case; Minox III/III-s belt case (note strap); case for separate meter. The left and right cases have a reinforced grommet for a chain.

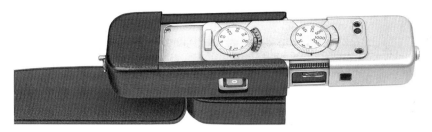

Flip-back case for Model LX. (Courtesy Minox GmbH)

with chains, and the user should find the proper case with factory ring. Catalog listings for the more common cases are given below.

Standard III-s case — No.6400
Standard B case — No.6405
Belt Case for III-s — No.6404
Belt Case for B — No.6406
Case for separate meter, standard — No.6401
Belt case for III-s AG type flash unit — No.6408
Belt case for B AG-type flash unit — No.6409
Leather case for early B/C flash unit — No.6403
Ever-ready Case B, BL — No.97275
Ever-ready Case for C — No.97265
Belt Case B, Bl — No.97276
Belt Case C — No.97266
Ever-ready Case LX — No.97267

Chains: Factory manufactured chains were offered early in 1950, almost coincident with the issue of the German patent No.1607991, dated June 7, 1950, for the chain. The characteristic feature of a genuine Minox chain is the appearance of beads at intervals along the chain. These were for measuring in the close-up range. They appeared in non-metric chains at 8, 10, 12, and 18 inches and in metric chains at 20, 24, 30 and 40 cm. These were not direct conversions, but convenient distances in each system. Readers should check the bead distances on any chain they might find at a camera trade fair with both metric and imperial scales to determine which chain it is. The chain was often referred to as a "safety and measuring chain" because a leather tab at one end could be hooked to a lapel, jacket, or trouser button.

Chains were provided with the earlier postwar cameras, but later became separate accessories, as did some camera cases. Catalog reference numbers for chains are listed below.

III-s and B chains — No.116

German patent No.1607991 issued on 7th June 1950

Chain for Minox Models III/III-s, B and C. Note measuring beads at 8, 10, 12 and 18 inches.

III-s and B chains, black, without tab — No.173-118
III-s and B chains, black, with tab — No.173-119
Leather tabs, sold separately — (6452) No.173-117
Chain for C — No.121

Gold chains came with the gold Model III-s and B and were never sold

as a separate item. The finish of black chains did not prove durable in use: some collectors have tried to restore them with paint but with little success.

Later chain designs for the LX and EC differed slightly in their fittings to their respective cameras. Catalog numbers are included in the section "LX and EC Accessories".

LX measuring chain in use (Courtesy Minox GmbH)

Copying Devices, Tripods and Clamps

Copy Stands: In addition to the Minox II/III enlarger copying arm (No.6751) which could be mounted on the enlarger column (see next chapter), there were separate copying stands and other copying accessories. A very early (circa 1954) copy stand design consisted of a universal copy arm (No.6752) on a vertical post which was fastened to a wooden baseboard. This early stand, sometimes referred to as a Minox Table Copying Stand, is very uncommon outside Germany.

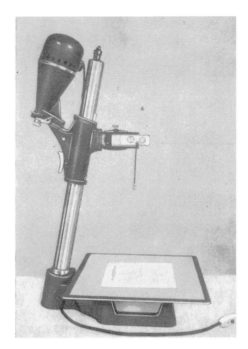

Minox held in Copy Arm attachment which fits the back of the post of the slant arm enlarger.

Copy Arm with adapter inserted to permit use of arm with any camera having a standard 1/4in. tripod socket.

A portable four-legged copy stand (No.760; No.6602; No.174-076), introduced in 1955, has proved to be the most popular of all Minox copying accessories. This stand consists of a combination camera clamp and head, the latter fitted to receive four legs which are color-coded in green, blue, yellow and red for proper fit and parallelism to the plane of the copy material. The legs are collapsible and mechanically fitted for

Above: Copying arm for attachment to enlarger with conical body/slant column. The alignment pins and knurled screw (on left) fastened the attachment to the column. Shown here with adapter removed. Note window for Minox camera lens at centre of photo. No.6751. No.77.

Below: Reproduction arm to hold Minox for copying on tubular column with wooden base board.

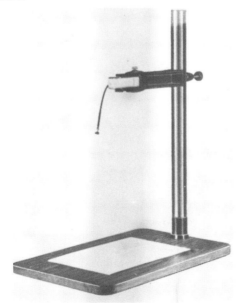

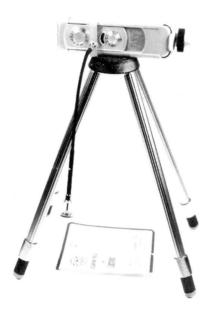

The very popular four-legged Minox copy stand with a Model III-s set up to copy a VEF Minox shipping ticket at 8 inch focus setting.

fast setting to positions at 8, 10, 12 and 18 in. from the copy plane, matching with corresponding focusing points on the camera dial. Up to 1975 there was a highly polished finish on the legs with some black trim on the head piece where the legs screwed in. A later design, marketed by Leitz/Minox, had black plastic finish legs (No.97321). The clamp in each case was satin chrome or part chrome and part black. The four-legged copy stand remains in the present Minox/Thayer line as No.23138, and is an indispensable accessory for anyone attempting to do serious copy work with the 9.5mm format Minox. There are two versions, one for Models III-s, B, BL, and C, and one for the LX with bracket in different position for cable release.

Tripods: The Minox tripod was conceived by Zapp as part of the original Riga system of accessories, but the author has been unable to find any evidence of its prewar manufacture. As early as 1950, the familiar chrome finish, ribbed pattern, swivel head, tiny tripod was introduced. The three legs of the tripod nest within each other, the inner leg containing a cable release. It was a very visionary and compact design, being only 7½x½in.

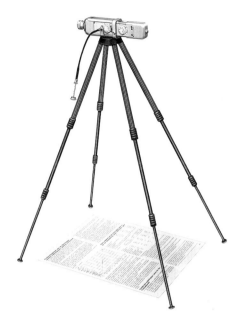

Above: Copy stand for LX with additional socket for cable release (Courtesy Minox GmbH)

Below: Minox tripod with LX-type tripod clamp. (Courtesy Minox GmbH)

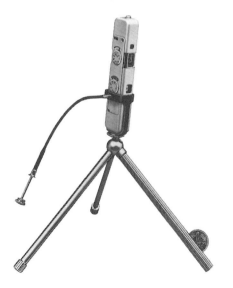

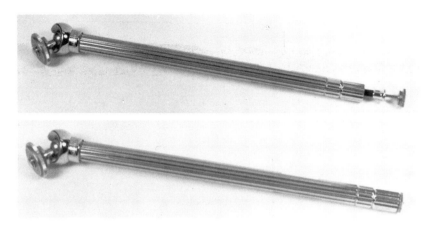

Top: The Minox tripod, legs telescoped and the top of the integral release just showing. Below: completely closed, measuring less than 8x1/2in.

Riga tripod clamp with variant of swivel holder attachment. Compare with the photo (below) showing another swivel-type attachment.

Modern tripod clamp shown with one variant of Riga tripod clamp

when collapsed. A ball and socket head, with threaded screw, locks into position when the largest tripod leg is tightened. As an emergency measure, there is a slot in this leg for a coin to unscrew it should the threads seize because of manual over-tightening. This latter touch is another example of the thought given to fine detail in Minox manufacture. The tripod remained in the line, starting with catalog No.70 under Kling, Leitz/Minox No.97337, and is presently cataloged as Thayer/Minox No.23101.

Tripod Clamps: Another item originally conceived as part of the Riga Minox system was the tripod clamp that adapted the Minox to tripod use. There were no tripod sockets in the design of 9.5mm bodies, and the tripod clamp fits round the body of the camera, providing a female bushing for tripod mounting with standard ¼in. thread. The clamp also permitted use of a cable release. Variations of the tripod clamp made at VEF were stainless steel inscribed with the VEF logo.

Postwar versions were in a satin aluminium finish; (No.6610) sold alone, the combination of tripod and tripod clamp (No.6620), and tripod, tripod clamp, and leather case (No.6621).

A tripod with case and clamp for the LX was offered by Leitz/Minox as No.97331, and tripod, case, and clamp for earlier 9.5mm Minox such as the III-s, B, and C as No.97330. The clamp for the III-s, B, BL, and C is presently cataloged as Thayer No.23102.

Binocular Clamp: The binocular clamp No.66120 or No.60 appeared

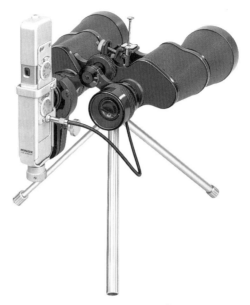

Binocular clamp in use with Minox LX. (Minox GmbH)

early in 1955, and is sometimes called the telephoto binocular clamp. This attachment consisted in part of the same type of 9.5mm camera body holder that was used in the four-legged copy stand and tripod clamp. In the case of the binocular clamp, however, the camera body-holding structure was attached to a pair of adjustable C-clamp jaws that would clamp around the eyepiece of a binocular. The combination was then used with most 9.5mm models as a telephoto lens attachment. Earlier versions (No.6612) were all in satin chrome finish. A later version (Leitz/Minox No.97306) had a black finish on the C-clamp jaws. Variants exist with highly polished alloy steel finishes produced in the 1960-1970 period. The jaws, which were adjustable from approximately one to two inches in inside diameter, could also be adapted for use with micro-scopes.

Walter Gray 9.5mm Minox Underwater Housing

Invented by Walter Gray, owner of Gray's Hollywood Panorama, a Hollywood, Florida camera shop, this accessory was a plexiglas and O-ring sealed housing for using III-s cameras underwater. The housing was

approximately 8x4in. Control extensions protruding from the plexiglas housing enabled the operator to cock the shutter, focus, and change shutter speed settings while underwater. A few units had provision for connection to an auxiliary artificial lighting unit, synchronized to the shutter. Introduced in 1957, sales were short-lived and the housing disappeared from the market in a few years. It was difficult enough for some users to master the Minox camera above the water, and the very small number of aqua-lung divers with a liking for Minox did not create the sales stampede that Gray had envisaged. Factory records in Germany do not indicate it was a factory authorized accessory, and it is included here mainly for its novelty and value as a Minox collector's item.

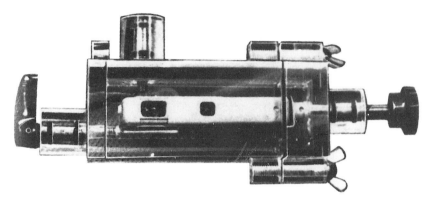

The Walter Gray underwater housing for Minox III-s. Gray tried to sell this idea to both the US Navy and the Minox factory but was unsuccessful. One of the rarer unofficial Minox accessories.

Film Processing, Englarging and Projection Equipment

Developing Tanks and Related Accessories

The earliest tank for the Minox was the bakelite Riga tank, designed as part of the Minox system that Walter Zapp conceived in early 1934. Basically the same in principle as the current tanks being sold today, the early Riga tanks were marked with "VEF" or "Riga" or some combination of both. The Riga tank also had a white lining in the filling spout, and the grooved spiral ribs of the Riga tank were more rounded than current model tanks.

Tank kits marketed in 1953 came with thermometers (kit No.6710).

Riga daylight-loading tank. Note white inner lining in top inlet of reel. (Courtesy Miniature Camera Magazine)

Late model daylight-loading developing tank with thermometer and filler ring.

Later, the thermometers were sold as separate items; No.6701. When the cassette change from 50 to 36 exposure and 15 exposure loads came, additional accessory filler rings were offered to adjust the tank spiral position in the tank and conserve developer. Late tank catalog numbers were No.97503 and currently No.25101.

In addition to Minox design daylight-loading tanks, Kindermann of Germany, and Nikor of the U.S. offered stainless steel open loading reels for 9.5mm Minox film. These reels had to be loaded in a darkroom or changing bag. The major advantages claimed for the open-type reel was better contact on all sides of the film, and more uniform development. The price paid for this, as compared to the daylight tank, was more patience and practice in loading skills.

Chemical Kits: Early chemical kits, around 1951, were made up in 15-set packets of developer, fixer, and wetting agent. They came in cardboard boxes with instructions and were cataloged as No.6720; 92; or 176-092. They suffered the disadvantages of most paper and plastic packaged chemicals, namely slow deterioration. With more conventional non-Minox glass and metal can packaged chemicals available, the early

Nikor and Kindermann stainless steel open-type, darkroom-loading reels.

Set of five glass ampoules containing fine grain developer, made by Tetenal for Minox. This set superseded the earlier 15-packet processing sets.

packets were discontinued in 1962. In 1967, newer packaging was introduced which consisted of 5-ampoule developer sets, sealed in glass with break-off tops. These ampoule sets were made by Tetenal of Germany, an established photochemical supplier of Beofin and many other reliable developers. The sets were cataloged as No.96 in early

Thayer sales lists, later changing to a modified top and Leitz/Minox No.97506.

Film Viewing Magnifier/Negative Viewer: One of the original items conceived by Zapp in Riga was this accessory which consisted of a magnifying lens mounted in the handle of a clamp-like holder which retained the negative or film strip under the viewer. It is often confused

Late model film viewing magnifier. This is not to be confused with the transparency cutter viewer which has a built-in sharp-edged bar to sever the desired individual image.

A rare variant of a Riga negative viewer. Note the VEF engraving. It was made of stainless steel or monel metal with rivets on the clamping arm. (Courtesy Hajimu Miyabe, Japan)

Above: Riga vintage negative holder (wallet type). The layout of five rows of ten negatives each has been used up to the present time.
Below: Early Giessen-vintage negative holder with its accompanying envelope for additional D&P information.

with the magnifier-cutter; described under Projection Accessories. Late catalog number for the magnifier-viewer was 97525 and the current Thayer is No.25011. An earlier listing carries it as No.94.

A rare variation of pre-WW II construction, bearing the VEF logo, was made of stainless steel and monel metal. It consisted of the two clamping arms riveted together, at the end away from the magnifier.

Negative wallets/envelopes: The negative wallets, or preservers, were made as early as the VEF-Riga era. The basic design consisted of five strips to hold 10 negatives each, with numbering of each negative from 1 to 50 under the strips. While materials have changed from celluloid to vinyl, glassine, and mylar, the basic arrangement remains the same. Imprints on the wallets varied with the era, starting with the VEF versions, and including "Minox-GmbH-Wetzlar" and "Minox GmbH Heuchelheim" and "Giessen". Pre-WWII Riga wallets are usually in a deteriorated condition because of the cellulose nitrate material.

There are also 30-exposure variations of the film wallets with three strips to hold ten frames each, numbered 1 to 30, for the 30-exposure color film marketed around 1954. These wallets were listed as Kling/Minox Catalog No.6911.

Print Albums: Two basic designs have been offered from 1953 to the early 1970's. These each held 102 prints, in either 2¾x3¾in. (No.120) or 3½x4¾in. (No.120A) sizes. The cover design was simulated brown or black leather with the Minox logo embossed in gold. Albums were approximately 6x9in. and were often confused with the *Minox Memo Binders*.

Enlargers and Accessories

The first Minox enlarger was the small bakelite pre World War II model developed in Riga at the VEF. This had an external transformer, and the lamphouse was a squat cylinder approximately 2½in. diameter, round on top and conical at the lens end. The easel was part of the enlarger, and prints up to 4x6in. could be produced. The base contained a matt-finish aluminium plate (part of the easel) which could be used for focusing. A chrome-plated button to the bottom right of the enlarger column could be depressed, raising the paper grip from the easel. A button on the transformer turned on the enlarger's low voltage lamp. Some of the light switch buttons were coated with luminous paint for easier location in the darkroom. While a larger size enlarger was conceived prior to WW II, the author has not come across any other size of prewar enlarger.

Riga bakelite enlarger with transformer.

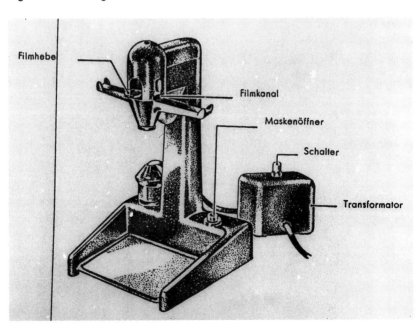

Page from German instruction book for VEF Riga enlarger showing various parts. The "Maskenoffner" is the push button which is pressed to open the printing mask. The "Schalter" is the switch on top of the transformer.

One variation of the Riga bakelite enlarger was made under USSR occupation. This has the words "Minox USSR" under the bottom front of the column, instead of the normal "VEF-Minox-Made in Riga" logo.

Immediate Postwar Enlarger: This was a larger format transition model, sometimes called the postwar Model I by collectors. It had a cylindrical metal housing approximately 3in. in diameter and 4in. high. The 2¼in. diameter column was vertical. The transformer built into the base had taps for 110, 120, 220, and 240 volts a.c. operation. The carrier was metal and took strip or roll negatives. Four easel sizes were available, and the lamphouse could be rotated 180° for larger projection on floors and walls. One distinguishing feature was the parallelogram-type hinge on the lamphouse. This model came on the American market briefly in 1950 and appeared in a Minox GmbH Wetzlar brochure Number W103e issued in August 1950. It is also described on page 121 of the May 1951 directory issue of *Popular Photography*.

Later Postwar Enlarger: Variously referred to as the Model II and Model III, and first marketed in late 1951, the distinguishing features of

An early post WWII enlarger with evidence of plating corrosion on the column. Note the Wetzlar logo and white oblong pendant-type switch lying on the easel. (Courtesy Les Lurey)

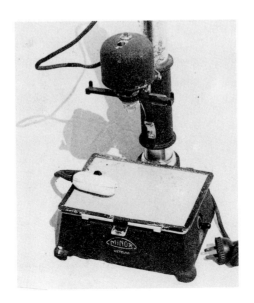

Close-up of squat head, vertical column, early post WWII enlarger. Part of right pivot of parallelogram mechanism can be seen. (Courtesy Les Lurey)

this more familiar enlarger are the slanting column, and the conical or funnel-shaped hinged lamphouse. This model had double condensers and a removeable opal diffuser disk. It was capable of 11x14in. enlargements on the baseboard. The lens was in a helical focusing mount and the negative holder had built-in curvature to complement the optical results on negatives made with the 4-element Complan curvilinear Minox camera lens. The film guide mark assembly was used in conjunction with the film carrier, which was a two-piece skeletal tray affair.

Accessories included a copy arm attachment, several sizes of negative carrier, print masks, red filter, mirror for large projections, and neutral-density filter for longer exposure times. This enlarger was one of the most popular 9.5mm Minox items, and designation numbers for the enlarger and its accessories are given below. In addition to usual a.c. operation and high-low dimmer switch built into the base, there was a series d.c. resistor available for operation from direct current supplies.

Enlarger Model II/III designations were Nos.6750, 6770, 80, 176-080.

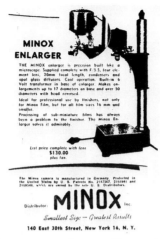

MINOX ENLARGER

THE MINOX enlarger is precision built like a microscope. Supplied complete with F:3.5, four element lens, 20mm focal length, condensers and opal glass diffusers. Cool operation. Built-in 6 Volt transformer in base of enlarger. Makes enlargements up to 17 diameters on base and over 50 diameters with head reversed.

Ideal for professional use by finishers, not only for Minox Film, but for all film sizes 16 mm and smaller.

Processing of sub-miniature films has always been a problem to the finisher. The Minox Enlarger solves it admirably.

List price complete with lens
$130.00
plus tax.

The Minox camera is manufactured in Germany. Protected in the United States by U. S. Patents No. 2147567, 2161961 and 2160548, which are owned by the sole U. S. Distributors.

Distributor: **MINOX** Inc.

Smallest Size — Greatest Results

140 East 30th Street, New York 16, N. Y.

Advertisement for early postwar enlarger with squat cylinder housing with an inset of the parallelogram breakaway feature. This model was made for a very short period from approximately 1949 to 1952.

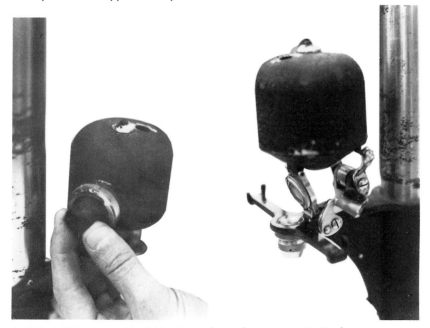

Left: Detail of postwar Model I enlarger lamp showing positioning lever.
Right: Model I enlarger housing with parallelogram lifted to show condenser and lens configuration.

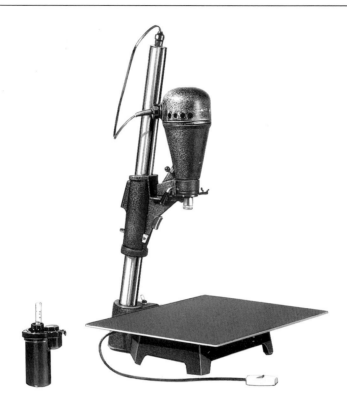

Above: The most recent model Minox enlarger with cone-shaped housing and slanting column. (Courtesy Minox GmbH)
Below: Special wrench used for assembling Minox enlargers, shown with column retaining ring which mounted underneath the easel.

The later Leitz/Minox designation was No.97560; the Minox-Thayer designation has been No.25402. As of August 1988, this enlarger was no longer offered for sale.

Enlarger Accessory Designations (Model II/III)
Spanner Wrench
Red Filter — No.6754
Easel with 4 masks — No.6753
Reflex Mirror — No.6755
Film Carriers, polished chrome
 Minox size (furnished with enlarger) — No.6756
 8mm cine — No.6757
 10mm square — No.6759
 16mm cine — No.6758

Final version of Minox color enlarger which was made for a few years in the late 1960's. Note the unusual "pancake" protrusion, near the top of the lamp housing, which carried the filters. (Courtesy Minox GmbH)

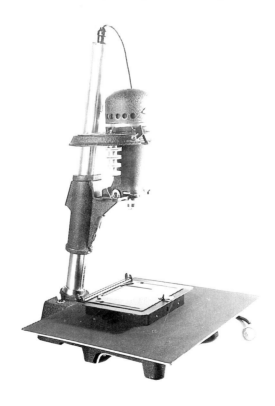

Copying Arm (fits on back of enlarger column) – No.6751

This arm is not to be confused with universal copying arm No.6752 described in "Copying Apparatus" section.

Lamps

High Intensity - 6 volt 6 ampere (No.84)(No.25008)

Low Intensity - 6 volt 3 ampere (No.25014)

Minox Color Englarger: For a brief period in the late 1960's, a very limited run of Minox color enlargers were made. These were separate-bodied enlargers and not attachments. They were characterized by a

Close-up of color enlarger "pancake" construction. This contained four rotating discs - three dichroic color filters and a neutral density filter. The position of the four filters was controlled by their respective milled knobs under the pancake. A mirror with "light pipe" can be seen to the right of the open segment which shows the readings on the discs. (Courtesy Les Lurey)

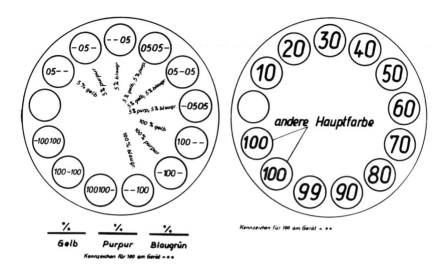

Left: Schematic for upper (supplementary) disc of Minox color enlarger. Note beginning combinations of 5 units each of gelb (yellow), purpur (magenta) and blugrun (cyan). These are followed by 100 unit combinations of each of the same colors.

Right: Schematic for second, third and fourth discs of Minox color enlarger. Each of these three discs has the 10, 20, 30, 40 progression of its own color plus 100 units of the two remaining colors.

pancake-shaped upper body projection which contained four discs. Each of the four discs was rotatable by means of a milled knob under the pancake.

The top disc, called a supplementary disc, contained various 5-unit and 100-unit combinations of the three complementary filters — yellow, cyan and magenta. The three remaining discs each had increasing 10-unit filters in yellow, cyan and magenta, plus 100-units of the two remaining complementaries. A combination of numbers and dots on the outer peripheries showed in an open segment of the pancake to tell the operator what total combination of filtration had been set up. Each disc had one blank opening for access down into the pancake and each individual filter was removeable for maintenance. Although many of these enlargers were used in commercial Minox color enlarging, they were dropped from the line in 1971, and remain scarce collector's items today.

Hollyslide Projector

The MINOX-*Hollyslide* Projector, manufactured in the United States, is provided with a 1:4,5 two inch focus lens and a 75 Watt projection bulb. Magnification of about 4 ft. diameter is obtained at a distance of 15 ft. from the screen. MINOX Color film can be projected without removal from the celophane transparency holder. Individual 2" x 2" selfsealing mounts are also available for both the MINOX-*Hollyslide* and standard 35 mm projectors.

Page from a 1950 circular describing the Minox Hollyslide projector which was not an official Minox factory-produced item as it was made in the USA.

Slide Projectors

Minox Hollyslide Projector: Offered briefly in the postwar period from 1948 to 1952, the Hollyslide was made by the Hollyslide Company, a subsidiary manufacturing operation of Morgan's Camera Shop in Los Angeles (Hollywood) California. An informal arrangement with Janis Vitols, at Minox Inc. in New York, allowed the use of the word "Minox" in connection with the project in the instruction books of the postwar period. The Minox logo does not appear on the two specimens the

The HP 30 manual slide projector, the first Minox factory-produced slide projector.

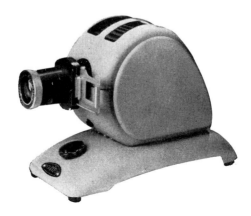

author has examined. Two inch square cardboard mounts with 8x11mm Minox cut-outs were offered with the projector, and the Minox color transparency wallets of that era could be used directly in the projector. The projector was of tin plate construction, with sliding lens tube focusing, and convection cooling.

Minox Factory Design Projectors: There have been four major projector designs in Minox development. These were the Model 30HP (the "HP" stood for "Home Projector"), Minomat, Minotact, and the most recent, HP24. Minox transparencies can also be projected in conventional, non-Minox equipment, but Minox GmbH claims superior image quality with the Minox optical systems.

HP30 (Catalog No.6300): Announced in Fall 1957, this projector had curved design lines and a levelling knob just below the lens barrel. It took 30x30mm mounts, and was available with a 35mm f/2.7 Minostar lens, or f/1.6 Minolux lens. With manual focusing, it used a 100 watt bulb, and was louvered at the top for ventilation. The basic color scheme was pearl grey, and it resembled a toaster in appearance! The top was removeable for lamp replacement, and slide-changing was accomplished with a two-slide manual shuttle-type changer in the lens mount assembly. The projector was only 9x6x5in. in size and weighed about two pounds. It came with a leather case.

Minomat/Minomat 40: Cataloged as No.40 and first available in 1961, the Minomat's chief identifying feature was the four button assembly on the top rear. These push buttons controlled on-off, slide change, and magazine release functions. Accessories for the Minomat included a No.43 wired remote control for changing slide direction, two-way focusing, and 16ft cable. An additional 16ft cable extension was available. A separate wireless control (No.44), using ultrasound, had three buttons for slide changing and focusing, and utilized 1.5 volt batteries.

Additional Minomat accessories included the No.42 automatic slide timer, with adjustable timing from 5 to 45 seconds, and interruption button for additional viewing time and special focusing. The Minomat projection bulb was type CEW-150 watt. The No.45 magazine held 36 Minox 30x30mm slides in a magazine, and a No.46 plug assembly provided audio synchronization connections to a tape recorder, if desired. The No.46 plug had an outlet for the No.43 wired remote control. The entire projector, with room for optional accessories, came in a custom fitted carrying case; 10x15x6¾in. The cover of the case held an internal projection screen capable of giving a 6½x9in. image at 28in. from the lens. Cabling on the Minomats can be quite perplexing at first glance, and a copy of the instruction book is invaluable to make sure all

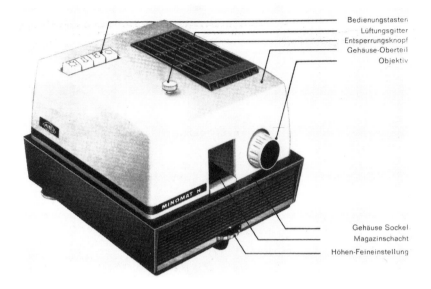

Bedienungstasten
Lüftungsgitter
Entsperrungsknopf
Gehäuse-Oberteil
Objektiv

Gehäuse Sockel
Magazinschacht
Höhen-Feineinstellung

The Minomat/Minomat 40 (first version) projector. Similar in front view to the Minotract, the Minomat had four push buttons on the top.

Remote controls for Minomat. No.43 wired type (left); No.44 ultra-sound wireless type (right).

the proper cords and plugs are present. Minor cable and plug changes were made during the course of manufacture of the Minomat, and its successor, Minomat N.

Minotact: Marketed in 1963, the Minotact was considered semi-automatic, and utilized 12 volt lighting. Its most distinguishing feature

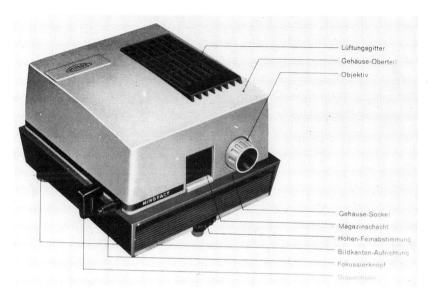

The Minotact semi-automatic slide projector with cylindrical focusing knob and lever-handled slide changer. Note opening for magazine in front center.

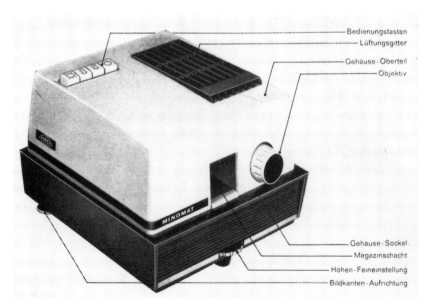

Minomat N projector, the fully-automatic version of the earlier Minomat. Note the "Entsperrungsknopf" (locking knob) for slide magazines on the top cover.

was the two side controls, one a knurled knob for focusing, and the other a right-angled lever for slide changing. The standard projection lens was the f/2.7 35mm Minostar. The justification for being semi-automatic was in the use of the manual slide-changing lever.

Minomat N: Introduced in 1965, this was a redesign of the Minomat, using a 12 volt, 100 watt system. The basic lens was the Minostar f/2.7. Black and white nameplates on the front usually distinguish the Minomat from the Minomat N. However, one characteristic feature of the N is the magazine locking screw on the top centre. The Minomat N was fully automatic with both slide changing and focusing accomplished by motor.

HP24/HP24A: The HP24 remote focus projector, introduced in 1971, incorporated a 24 volt, 150 watt tungsten-halogen bulb with double condensers. A new f/2.7 Minogon lens design provided greatly improved color projection. The hand held control (wired) had forward, reverse, and focusing buttons. The distinguishing feature of the HP24 is its rectangular shape with the slide magazine moving in an open channel to one side of the lens. It is approximately 5x8x13in. The early Thayer catalog number was 404 in 1971. This became No.97615 under Leitz/Minox. An autofocus version, the HP24A, was offered as Leitz/Minox No.97617. The HP24 and 24A are in the current Thayer line as 24303 and 24304, respectively.

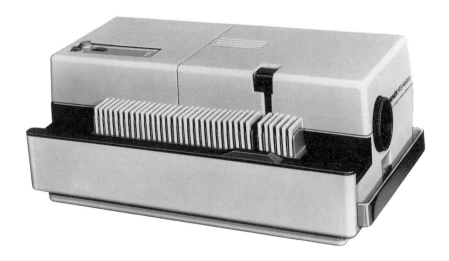

HP 24 Minox projector. Note slide magazine to one side of main body housing.

Projection Accessories

Slide Mounts: Early Minox slide mounts were in two pieces: one piece was slotted to receive tabs from the opposite piece. The slide was sandwiched between glass plates, and the two outside pieces were held together by putting the tabs through slots and then bending the tabs over. Later mounts were of the plastic, fold-over type. Mounts included the 2x2in. cardboard type (No.56) (No.6920) for conventional projectors, and the 30x30mm type No.58 for Minox projectors.

Slide Magazines/Trays: Slide magazines for Minomats and Minotacts were rectangular box-like holders with angled separators on one side. Tops were recessed with two ribs running the length of the magazine, one rib on each side. One side was numbered from 1 to 36. Minox slide

Above: Late folding-type 30x30mm Minox slide mount (left) compared to conventional 2x2in. mount.

Below: Minox transparency mounts which were 2x2in. on the outside but had 8x11mm opening for the projected material. Circa 1954.

Early 30x30mm slide magazine used in Minomat and Minotact projectors.

magazine design was standardized between the Minomats and Minotacts, and the magazines were cataloged as No.45 and (No.175-045). Slide trays for the later design HP24 projectors were open rectangular separators. These were sold in sets of three as No.049, Leitz-Minox No.97635, and are presently cataloged as Thayer-Minox No.24424.

Slide Safes/Slide Boxes (No.55) (No.6923): These were of plastic, dust-proof construction; 3¼x6½x1½in. and made to hold 50 metal or glass slides in indexed and numbered slots. They were the least expensive and most valuable of all the projection accessories, considering the ease with which the small format Minox transparencies picked up dirt and became scratched.

Slide Binding Kits (No.54) (No.6922): These came in cardboard boxes, complete with enough frames, masks, and cover glasses to mount 50 slides.

Transparency Viewer and Cutter: This is a hand-held device with magnifier. The film strip is held between two plates, positioned, and then a slight pressure on the handle cuts out the desired transparency. The transparency viewer-cutter is often confused with the negative viewer, described above, which did not have a cutting function.

Above: Minox transparency viewer and cutter. Note hinged portion from middle of handle extending towards lens housing. Compare with Minox negative viewer shown earlier.

Below: Two variants of the magnifier-cutter. The top one automatically cuts and inserts the frame into the mask and mount while the bottom one just cuts out the selected frame.

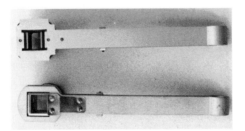

110 Format Minox Cameras

Introduced at the 1974 Photokina in Germany, the Minox 110 format camera was something of a hybrid to Minox users and collectors. The principle model was the 110S which had a 25mm,f/2.8 lens that was a

Minox 110S. Note socket for flash cube on top right of body.
(Courtesy Minox GmbH)

F110 electronic flash unit. (Courtesy Hove Camera Company)

4-element Tessar-type design. Besides the unmistakable 110 size body, the distinguishing features of this model were a rangefinder focus slider at the top right-hand end of the body, and a flash cube socket at the top left-hand end. Lens aperture setting was accomplished with a knurled wheel in the top center of the body. Further distinguishing features were the alligator-jaw front-opening doors, and two Mallory 625 (or equivalent) cells held internally in the hinged back of the camera in such a way as to ensure renewed electrical contact whenever the back was opened. A variant, designated as the Minox 110L, with f/5.6 lens was made up in small prototype runs, but never marketed commercially. The most common body color was black, with limited runs in brown, and a smaller number in white. Shutter actuating buttons were primarily red in color and approximately 8mm or ⅓in. in diameter, at the rear top right of the body. The rangefinder was the superimposed-image type, in a small area which appeared in the center of the viewfinder.

A special electronic flash unit, the F110, was made for the 110S. It snapped onto the left-hand end of the camera (from the user's point of view) and had the same profile as the camera so when fitted it elongated the camera. It was provided with its own leather purse case.

35mm Minox Cameras

Although all 35mm models of the Minox might appear to be the same at first glance, there are several distinguishing features that readily identify each model.

The most comprehensively detailed descriptions and instructions for use of the 35mm Minox can be found in the book *Minox 35-Spitzentechnik im Paschenformat* (ISBN 3-925334-02-5), written by Rolf Kasemeier and published in 1986 by G+G Urban-Verlag, Munich, West Germany. Unfortunately this book is not available in English. Mr. Kasemeier, now retired, was advertising and public relations manager of Minox GmbH from 1950, and is the authority on products and activities of Minox from that time up to his retirement in 1987.

Accessories in this section, unless otherwise noted, are specific to 35mm models only. The regular Minox pocket tripod, described above, is one accessory mentioned in advertising for the 35mm models.

As in the case of 9.5mm models, 35mm models are made with focusing scales both in feet and meters. The basic case color is black, with a few color variants as noted under relevant models. Leitz-Minox and Thayer-Minox catalog numbers are given, where known. The Leitz series falls in the 97000 range, and the newer Thayer catalog numbers fall in the 10000 number range. Although many of the camera body covers are marked with a designation, additional identification points such as color of shutter release, or winding knob markings, are given to reinforce positive identification.

Minox 35 EL

Introduced at Photokina 1974, this was the first Minox 35 in the line. Its distinguishing features are (1) dark red shutter release button (2) uncovered flash shoe (3) no model designation under the word "Minox" on inside body plate and (4) no dot on film rewind crank. It had aperture-priority automatic exposure. The lens was a Color-Minotar

Minox 35 EL in ever-ready case and with accessory lens hood fitted.
(Courtesy Minox GmbH)

35mm,f/2.8. Some very early EL samples had insufficient opaque filler in
the body resulting in a tendency to fog high speed film when the cameras
were left in bright sunlight.

Minox 35 GL (97012)

Introduced in February 1979, at first glance the GL is an EL lookalike.
However, upon closer inspection, the GL has (1) a bright orange shutter

Special shutter release adapter for Minox 35 GL.

release button (2) covered flash shoe contact (3) white dot approximately 1.5mm in diameter at one end of film rewind crank, (4) milled grip of film advance wheel wider than on EL. Because of its unusually sensitive touch, a special shutter release adapter (97261GL) was marketed to allow attachment of a cable release without premature shutter trip from just the release alone. The accessory also adapts the camera to an external self-timer.

Minox 35 GT (10752)

First added to the 35mm line in September 1981, the makers have made identification of the GT obvious by putting the model designation "35 GT" under the word "Minox" on the inside front body plate. As further identification (1) the shutter release button is yellow (2) there is a red LED over the letters "N" and "O" in "Minox" (3) the dot on the film rewind crank is silver-white and 2mm in diameter (4) Redesigned film advance lever. An additional feature is the electronic self-timer.

A 35 GT variation exists, made in 1984, in the run of 5,555 of an olive-green color and popularly called the Golf.

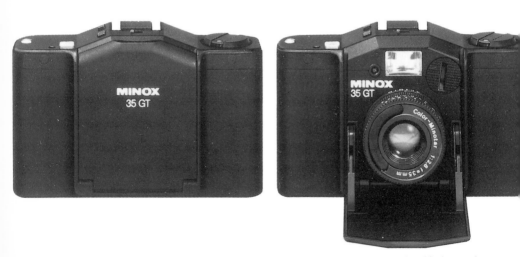

Minox 35 GT has large white dot on rewind lever. Battery test, backlight, and self-timer switches clustered on top plate. (Courtesy Minox GmbH)

Minox 35 PL

This was added in 1982, with "35 PL" appearing under "Minox" on the

inside. It had fully automatic program exposure control. Additional distinguishing features are (1) green shutter release button and (2) two LEDs -- red and green − in front of flash shoe. The red LED over the "N" and "O" on the "Minox" appears as it did on the GT. The PL, like the GT, is a lever film wind model.

Minox Models 35 GT, 35 PE and 35 PL. The 35 PE had flash incorporated in the elongated body. The 35 PL had two LED's on the top plate, compared with three on the PE and none on the GT.

Minox 35 PE

This model was introduced in 1983, also with program exposure control, and is designated on the inside plate as a "35 PE". Two additional, unmistakeable features are (1) three LEDs − red, green and yellow − at top front of body and (2) built-in flash, which gives the body a distinctive, long, non-symmetrical look when viewed from the front.

Minox 35 ML (10742)

The ML was added in Spring 1985 and introduced a new body shape. It had both program and aperture-priority AE modes. It is marked "35 ML" under "Minox" on the inside body plate. The additional distinguishing features are (1) corners on front door are squared off, instead of angled (2) top center of body is not sloped off toward each end as in the EL, GL, GT, PL, and PE. One other unusual feature is that the battery compartment cover is five-sided in the ML, instead of the more common round cover with slot.

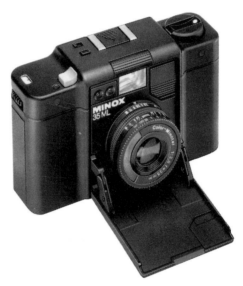

Model 35 ML. Note nearly-square edges where top sides meet center of body, unlike 30° angled construction of top of EL, GL and PL. Most distinguishing feature is five-sided battery housing cover at top right of lens.

Minox 35 MB (10772)

Also added in 1985, it carries the designation "35 MB" under "Minox" on the inside plate. It resembles the ML in body shape and the five-sided battery compartment cover and two LEDs over the model designation, but offers aperture priority only.

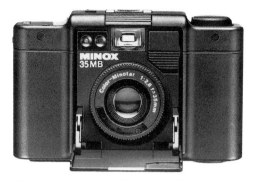

Minox 35 MB. Similar in all respects to 35 ML but offering aperture priority only. (Courtesy Minox GmbH)

Minox 35 AL

The 35 AL of 1987 is a simplified model with pictographs for sun, partial cloud, and cloud to set the aperture. It has a fixed-focus, 5ft. to infinity, 35mm, f/4 Color-Minar lens. Body shape is of the earlier form and it is available in black (10711) or white (10712).

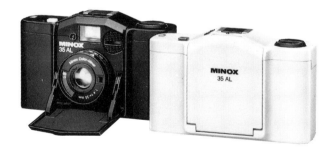

Left: Minox 35 AL - black and white variants. (Minox GmbH)
Right: Top view of white variant 35 AL. Note large dot on rewind and the pictographs of cloudy, partially cloudy and sun on the top right side of the lens

Minox 35 GT-E

The GT-E of 1988 has a MC-Minoxar f/2.8 lens. The model designation "GT-E" appears in block letters approximately 3/16in. high in front of the winding lever, and on the top right rear of the body. The shutter release button is red. The body ends carry a pattern of raised pips to improve grip.

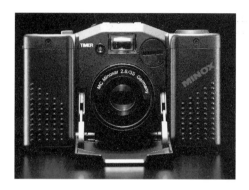

The Minox GT-E differs from the earlier GT in having an MC-Minoxar f/2.8 lens and raised pips moulded into the body ends for better grip.
(Courtesy Minox GmbH)

Minox 35 AF

Introduced at Photokina, 1988, the 35 AF is the first of a line of Minox auto-focusing 35mm cameras. The lens is a Minoxar 32mm, f/3.5, with EV from 8.5 to 16, electronic shutter release, and provision for auto-DX film

Minox 35 AF. (Courtesy Don Thayer)

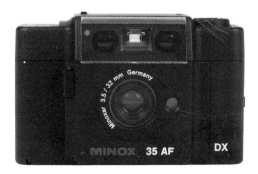

coding in ISO 100, 200, 400, and 640. The autofocusing system is an active four-zone infrared system with a measuring width of 4°, and focusing down to 27.6in. Just slightly larger than the non-autofocus 35s, it also has an auto-threading film feature.

35mm Flash Units

The major accessory for the 35mm models, with the exception of the 35 PE, was the separately-attachable flash units. These were broadly designated as "C" and "M" series, some of the flashes being partially dedicated, and others being fully dedicated. Some combinations of flash model and camera model were totally unsuited to each other functionally. The various possible combinations of flash and camera are discussed in detail in the aforementioned book *Minox 35*. Only brief descriptions will be given here.

TC 35 (22095) C Series: The TC 35 has the highest light output in the

TC 35 flash on 35 GT body. This is the "full length" flash. Note the center arch to clear the raised middle portion of the camera top plate. (Courtesy Minox GmbH)

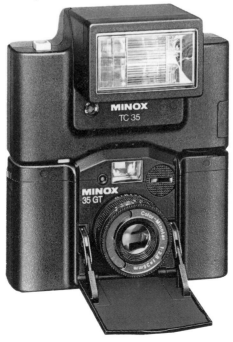

C series, and fits all 35mm cameras in the Minox series except the Model ML. The flash body has the same overall length as the camera body. The rear of the TC 35 has an ASA/DIN metre/ft. distance slide-rule computer, and three LEDs for aperture and ranging indication. The computer is a three-element one.

FC 35 (22094) C Series: This unit has a two-element computer and fits all cameras except the ML. The FC 35 body is only the length of the main camera body center plus one camera side panel. The FC 35 is not designated with the model number on the front, but it appears on the upper rear back. A simpler table and switch arrangement is utilized in the FC 35. A variant of the FC 35 is the FC 35 ST in which a series thyristor is used to conserve power and improve recycling time.

FC 35 ST flash unit, with series thyristor. The earlier FC 35 was similar in appearance but had no model designation. (Courtesy Minox GmbH)

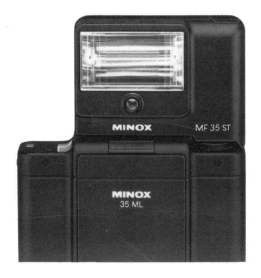

MRT 35 (22113) M Series: This is a full-camera-body-length flash unit that looks like a twin of the TC 35, but is made especially for the 35 ML camera. The vario-computer design can be used for spot or area flash.

MF 35 (22111) M Series: This is similar to the FC 35/35 ST units in length. The model designations "MF 35" and "MF 35 ST" appear on the unit for identification. The "ST" suffix indicates the series-thyristor version.

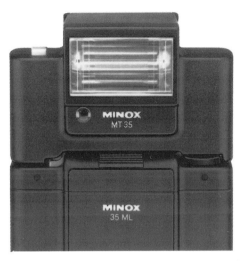

Above: MT 35 flash on 35 ML body. Flash occupies full length of camera body. (Courtesy Minox GmbH)
Below: MF 35 ST flash mounted on 35 ML body. Note that flash occupies only 2/3 length of body. (Courtesy Minox GmbH)

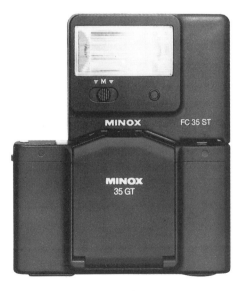

Other 35mm Accessories

Ever-ready/Belt-Wrist/Shoulder Cases: A wide variety of cases have

Above: Every-ready case for 35mm Minox camera. (Courtesy Minox GmbH)
Below: Burgundy leather pouch type carrying case for 35mm Minox cameras.

been offered with the Minox 35 cameras. The three major designs are the ever-ready, belt and wrist, and fashion wrist cases. The latter is a linen/leather combination. A shoulder bag which holds an additional flash unit is also available. In addition, individual leather cases for each flash unit are offered.

Current catalog numbering is given below.

Ever-ready Case – ML, MB, GT, AL	14804
Belt and Wrist Case – ML, MB, GT, AL	14806
Fashion Wrist Case – MB, GT, AL	14808
Shoulder Bag – ML, MB, GT, AL	14807
Leather Case – MF 35/35 ST, FC 35/35 ST, FA 35	22894
Leather Case – MT 35, TC 35	22895

Filters and Close-up Lenses: A wide variety of filter and close-up lenses have been offered for the Minox 35mm cameras. The list is taken

from the Leitz/Minox catalog of 1979 and reproduced below. The current line is narrowed down to a skylight filter with lens shade (23011) and gray filter with lens shade (23014).

List of auxiliary lenses and filters available for Minox 35mm cameras under Leitz-Minox US distribution 1979. (Courtesy E. Leitz Inc. USA)

Close-up lenses.

Slip-on type. With normal focus at 3 feet, + 1 lens brings you to 18.7 inches; + 2 to 12.6; + 3 to 9.6.

Close-up lens + 1	433527
Close-up lens + 2	433528
Close-up lens + 3	433529

Filters.

Slip on type. Must be removed before closing camera. Distance scale can be read while filter is on.

Skylight with lenshood	97314
Neutral density with lenshood	97315
Neutral density 2x	433535
Neutral density 4x	433536
UVA	433501
Yellow-orange	433502
Yellow 1	433503
Yellow 2	433504
Red-orange	433506
Yellow-green	433507
Yellow-orange	433505
Green	433508
Light red	433510
Dark red	433511
81C (KR3)	433516
81EF (KR6)	433517
85A (KR12)	433518
82A (KB1.5)	433520
82C (KB3)	433521
80C - 80D (KB3)	433522
80B (KB12)	433523
80A (KB20)	433524
POP blue	433560
POP green	433561
POP orange	433562
POP red	433563
POP purple	433564
POP violet	433565
Soft focus I	433556
Soft focus II	433557

Advertising and Promotional Items

Literature

Starting with the original instruction books for the Minox equipment made at VEF in Riga, Latvia, virtually every piece of stand-alone (ie non-magazine or newspaper advertising) has become a collector's item. The

Instruction books for the Riga Minox camera in German and English, plus the instruction book in English for the VEF Riga developing tank.

Minox logo combined with some theme for the use of the Minox was usually the force responsible for the literature's popularity with collectors. The pre-war literature is especially desirable because of the artwork of Adolfs Irbitis, VEF's industrial design chief.

The advertising pieces from the VEF era include instruction books for the first models of enlarger and developing tank, as well as the instruction books for the Riga Minox itself. The latter are extant in several languages including French, German and English. A rare piece of early literature, *The Turning Point*, was about 5x7in. in size, had 32 pages, and depicted all the features of the Minox in semi-cartoon fashion.

The postwar literature from 1948 to 1953 is especially interesting since this was the period of redesign and early large scale commercial marketing of Minox from Germany. An 8-page fold-out instruction book for the Minox II, and two advertising brochures titled *The Tiny Camera of Great Performance* and *Maximal Performance in Subminiature Size*, were in the ephemera of this era, followed by a very collectable brochure in 1953 titled *Most Fabulous Photo Instrument of our Times*. The mid-

The cover of the brochure *The Turning Point*. This was designed by Adolfs Irbitis, industrial designer at VEF. (Courtesy Richard Conrad)

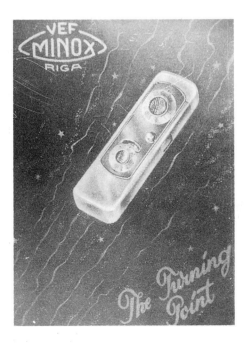

1950's to mid-1960's era produced several Minox advertising collectibles which included an 8x10in. black, orange and yellow corporate gift-giving brochure, a 16-page 3x8in. booklet titled *The Minox for Business, for Pleasure* and a 10in. square blue-covered spiral bound sales counter item titled *The Magnificent Minox camera and its ultra-miniature accessories* which listed all Minox cameras and accessories up to April 1964. Interspersed through these years were many individual two- and four-page flyers on the Minox B, and from Minox Processing Laboratories concerning exposure tips, and even savings of "over $49 on a new Minox III-s camera" (when the Model B threatened to overshadow sales of the III-s completely)!

While the instruction books for later models such as the C and LX are collectible, they exhibit modern advertising art influence, and a trend away from line illustrations and detail shown in much of the earlier literature. One clever ad of the early LX years in 1979 was the now famous *The Minox Spy Camera...It's not just for beautiful spies any*

A page from the rare brochure *The Turning Point*. Note the cartoon-like characters in the lower corners. (Courtesy Richard Conrad)

Two brochures for the Minox II from the 1949-1950 Wetzlar era.

more brochure, put out during Leitz distributorship days. The Russian spy theme ads run under Hasselblad's subsequent distribution era in 1981 thru 1987 have become classics, although no separate spy theme literature was ever issued by them outside the magazine format.

House Organs: Although not advertisements in a strict sense, these magazines and newsletters also carried editorial accounts of what was new in Minox technique, and stories of the various situations people found themselves in as a consequence of using the Minox. There were three major house organs written around the Minox. These were the

Booklet issued in January 1953, pointing out the features of the Minox III. Note that the address for Minox Inc. was 140 East 30th Street - Janis Vitols' operation with Donald Thayer Sr.

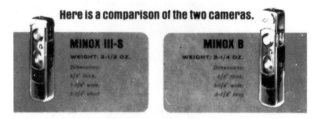

The brochure printed in both green and red versions, circa 1962, in an effort to revitalize sales in the Model B introduced four years previously. Saving $49 on a Minox was a tempting attraction in those days.

Above: Corporate gift-giving brochure, designed by Don Thayer and Baker Advertising Agency, circa 1965. A bright orange and black cover caught many executives' attention when it came to sales awards and retirement gifts.

Below: Literature from the mid-1950's - the P.O. Box 94 era of the Minox Processing Laboratories. The artwork is partially the idea of Donald Thayer Sr.

Above: "Welcome to Minox" greeting card issued in the mid-1950's to visitors at the Minox GmbH factory. This was the inspiration of Donald Thayer Sr.

Below: Minox brochures, circa 1970, featuring the Berkey Processing Service (not to be confused with the Minox Processing Labs run by Don Thayer), the Models C and BL.

Above: An early (circa 1956) and late (circa 1972) brochure showing the progress of Minox flash accessories for Minox and other cameras.

Below: A colorful booklet, issued in the 1980's by Know Photo of Japan, extolling the virtues of LX, EC and 35mm Minox cameras and their accessories, as well as listing their prices. Japanese text but extremely captivating four-color high resolution graphic artwork.

POUR PRISES DE VUES VERTICALES

les quatrième et cinquième doigts de la main droite sont pliés. Pour le reste la position reste la même que pour la prise de vue horizontale.

La main gauche est appuyée au front et la main droite sur la joue. Dans ces deux positions on vise avec l'oeil droit.

Above: Page from French version of Riga Minox instruction book. The photograph is noteworthy since it features Mrs. Nylander, the wife of Walter Zapp's lifetime friend.

Below: Two advertising brochures featuring the Model B, circa 1959.

Minox Memo, published by Minox Processing Laboratories from Spring 1956 to 1972, *Der Minox-Freund* which ran from November 1958 to Spring 1970, and was sponsored by the factory; Minox GmbH, and the shorter-lived *The Minox Letter* under the aegis of Kling Photo. The latter ran from 1967 to 1971. A special binder was made up to hold the *Minox Memo*.

Minox Jewelry

High on every Minox collector's list of desirables are the distinctively detailed jewelry items. The news of Minox jewelry broke in the Winter 1963 issue of the *Minox Memo*, where a limited amount was offered just in time for the 1963 Christmas holiday season. Also included in that same issue was a first-class reply card, giving details of proper ordering numbers. The series was designated both with "J-numbers" in the *Minox Memo* and series numbers from 178-200 in the Kling-Berkey sales

Three house organs issued for Minox. Left to right: *Der Minox Freund* (Minox GmbH); *Minox Memo* (Minox Processing Laboratories); *The Minox Letter* (Berkey Photo).

DISTINCTIVE

JEWELRY — IDEAL CHRISTMAS STOCKING STUFFERS

stunning, custom-made charms

pendants and earrings

J-8 Sterling silver charm/pendant, each$4.95

J-9 14K solid gold
charm/pendant, each$24.95

J-10 Sterling silver earrings, a pair$9.95

J-11 14K solid gold earrings, a pair$47.50

All above are exquisitely gift packaged
in jewel cases.

delightfully detailed cuff links tie and scarf tacks

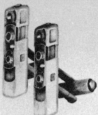

#J-1
In silver oxidized hand-relieved finish and magnificently gift packaged.
$2.95 a pair

#J-2
In Hamilton gold plated rose satin finish, packaged in a jewel case.
$3.50 a pair.

#J-3 #J-4

For both Minoxers and Minoxettes (lady Minoxers), these Tie and Scarf Tacks double as lapel pins or costume jewelry. Choose **#J-3**, silver oxidized hand-relieved finish at **$1.50** each or **#J-4**, Hamilton gold plated rose satin finish at **$1.95** each. Gift packaged in jewel cases, of course.

decorative tie and scarf bars

Most everyone wears a tie or scarf. Your choice of the tie bar finishes assures the perfect accessory touch for any ensemble.

#J-5 Silver oxidized, hand-relieved finish, each **$2.95**

#J-6 Hamilton gold-plated,
rose satin finish, each$3.50

#J-7 Silver oxidized, hand-relieved finish, each **$2.50**

FOR THOSE WHO PREFER A TIE TACK AND CHAIN

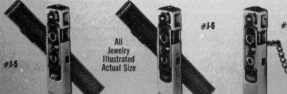

#J-5 All Jewelry Illustrated Actual Size #J-6 #J-7

Listings for Minox jewelry which appeared in the *Minox Memo*.

Individual tie/scarf bar in plastic box. The detail is sufficient to recognize that the camera is a Model B.

literature, and the numbers are detailed below. The jewelry campaign was reinforced with another reply card in the Spring 1964, and again in the Winter 1965 issue of the *Minox Memo*. Jewelry listings appeared randomly until 1971 when the novelty finally wore off.

Minox Jewelry Catalog Numbers/Descriptions

Memo No.	Kling-Berkey No.	Description
J-1	178-201	Cuff links — oxidized Silver
J-2	178-202	Cuff Links — Hamilton Gold Plate
J-3	178-203	Tie/Scarf Tack — oxidized Silver
J-4	178-204	Tie/Scarf Tack — Hamilton Gold Plate
J-5	178-205	Tie/Scarf Bar — oxidised Silver
J-6	178-206	Tie/Scarf Bar — Hamilton Gold Plate
J-7	178-207	Tie Tack/Chain — oxidized Silver
J-8	178-208	Charm/Pendant — Sterling Silver
J-9	178-209	Charm/Pendant — 14ct. Gold
J-10	178-210	Earrings/Pair — Sterling Silver
J-11	178-211	Earrings/Pair — 14ct. Gold

While Minox jewelry might have been the most unique of all Minox sales promotion schemes, other Minox items were conceived to place the logo before prospective Minox buyers in unusual ways. Appearing in 1959, the first versions of fitted carrying cases, plush-lined with blue felt, called "Diplomat" (No.6420), and "Embassy" (No.6423), were offered.

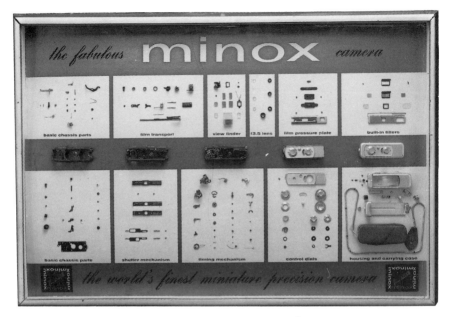

Above: The Model III-s Assembly Demonstration Board

Below: Holiday gift center display case (circa 1968) showing copy stand, binocular clamp, filters for Model B, right angle and reflex B viewfinders etc.

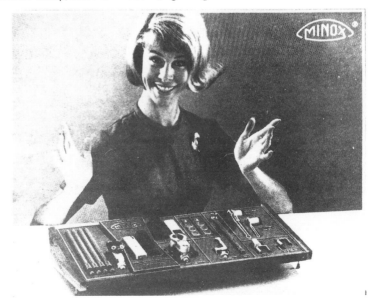

The Diplomat was the smaller of the two cases, measuring 17x10x3in., and held a III-s plus B/C flash, copying stand, separate meter, binocular clamp, tripod, 8 boxes of film, tripod clamp, negative viewer, and viewer/transparency cutter. The inner lid had a pouch for literature. The Embassy (sometimes referred to as the "Embassy Deluxe") was 11x20x3in., and could hold an additional model B. The two cases were covered with various grained leathers in light brown or gray colors. The idea grew out of a few sample cases made for selected dealers in 1956, and the cases were jointly conceived by Don Thayer Snr. and Kurt Luhn of Kling.

Demonstration and Display Items

Minox Assembly Demonstration Board: Made up in the 1955-1962 era, these boards were approximately 2½x4ft., and were either wall-hung or put in show cases and store windows. They depicted the various stages in assembling a Minox III-s or B camera. The boards were divided into sections which included the basic chassis, shutter mechanism, film transport, viewfinder, lens assembly, and control dials. The boards were made up in limited numbers; the records from Kling indicated 118 contracted for and 97 delivered.

Holiday Gift Center Display: These were made up in 1968 for select dealer locations and the 1968 Christmas Holiday season. They measured approximately 11in. deep by 38in. long, and held all the major camera accessories available for the III-s and B Models. At one end of the case was the four-legged copy stand outfit, followed by the ME-1 strobe, next to a Minox III-s and B. Beyond them were the negative viewer and transparency cutter. Finally, there were the auxiliary viewfinders. B/C flash, tripod clamp and auxiliary filters could also be found on the display, which could be tilted up for counter or show case use. They were not made up expressly as an item for sale to a Minox user, but are nevertheless one of the advanced collector's items.

Dealer Display Sales Cases: One major design of dealer display case had a curved plastic front with the Minox logo in lower case letters in the lower middle front of the case. The case also had two shelves, in addition to the case bottom itself, and the dealer could arrange Minox cameras and accessories to suit his sense of whatever would sell the most at any given time. This particular design measured 5ft across, 3ft high and 20in. deep. Custom-fitted salesmens' cases were also made up in small numbers.

Dealer Counter Signs: These varied, and usually had the word "Minox"

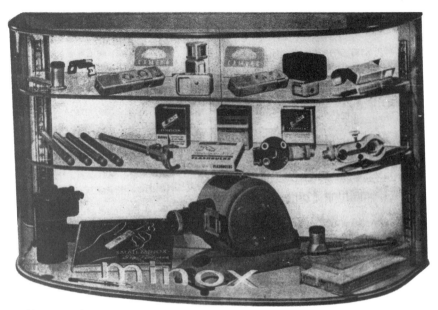

Above: Dealer Display Sales Case with Model HP 30 projector in lower center.
Below: Cast metal dealer's counter display sign, early 1950's.

in logo form engraved or silk-screened on metal, wood or plastic. In some cases the dealers were allowed to make up their own, subject to factory approval through the sales representative. Unfortunately, as in the case of spurious "gold" Minoxes, a few counterfeit signs are known, and the prospective collector should take pains to establish the provenance of the item first.

Contest Trophies

Announced in late 1956, the First Annual Minox Photo Contest offered

A custom-made sales case holding four-legged copy stand, tripod clamp, Minox C, viewer-cutter, viewer, film, and other Minox items. The top of the case had a fold-out compartment for sales literature. (Courtesy Don Thayer)

prizes for pictures taken between August 1 1956 and July 31 1957. The first prize in each of the "Business" and "Pleasure" divisions was an inscribed trophy which held a gold Minox shell inside a highly polished nickel or chrome plated ring. The ring was approximately 5in. in diameter, and the model was usually a III-s throughout the life of the contests which ran to the 5th contest in 1963-1964. Variants of the trophies included the presence or absence of gold eagles, rectangular, and truncated 4-sided tapering bases of various heights They were made up in random lots, much like bowling trophies. In a few instances, the

One of the First Prize Minox trophies which held a replica gold III-s body inside a chrome ring. The man in the photo is Joe Marx, one of the Minox's most avid users in its heyday of the 1950's and 1960's, who produced wall-size panoramic enlargements from negatives using the Minox 9.5mm camera.

gold shells have been cannabilized from the trophies to create gold Minoxes, by adding the working components. Such shells can usually be detected by the presence of four small holes at the ends, which originally received the mounting screws to hold the shell in the ring.

Duet Gift Pack

Marketed briefly in 1957, the Duet Gift Pack was an attempt to garner some of the lucrative corporate business incentive market, and also provide something a bit different for business gift giving. The package consisted of a Minox exposure meter and III-s camera, each with its own case, and each wrapped in gold foil, in a gold and black box with a plastic cover. The theme at the top of the package was "Minox – World's Smallest Photography System", underneath which was the sub-theme "The Gift Supreme". The promotion was partially an attempt to ride on the heels of the limited issue gold III-s cameras, at a competitive pricing point geared to a corporate buyer. The packaging was similar in style to the Minox Film Quartet promotion described in the section on Minox Films.

CHAPTER 16

Minox Microform and Related Equipment

Minox microform (microfilm, microfiche, microdot) equipment is among the less common collectibles, especially in the United States. This is partially accounted for by the bulk and cost of the high quality Minox items of this type as compared to many mass-produced American microform units built to sell on price first. There are some smaller Minox microform equipment that is often acquired by the advanced collector.

Model MD Reader: Introduced in 1955, the MD is 15x19x22in. and weights 24 pounds. The projection screen is approximately 11in. square, and the light intensity is high enough for use in ambient lighting situations. The ground-glass screen can be removed for short-throw projection onto a small screen or wall.

Below left: Minox Model MD microfilm reader, circa 1965.
Below right: Minox Model 811 microfilm reader.

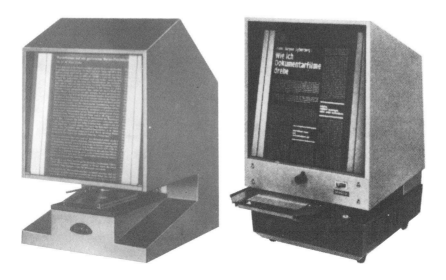

A variation of the blue envelope film sleeve, called a "document sleeve" has been sold in connection with Minox microfilm readers. This had wider channels and could be pressed flatter than the usual 50/5 strip Minox negative envelopes and had four instead of five channels. The MD reader was focused by turning the lens mount.

Model 811/M811: Introduced in 1977, focusing was accomplished by a knob on one side of the front. The distinguishing characteristic was the top slanting downwards towards the back, whereas the MD had a pitched roof appearance.

M1 Portable: Not yet available in the United States, the M1 reader for fiche is approximately 10x12x3in. It can be carried like a briefcase and propped up for viewing at an angle.

Mikrodot Gerat: A most unique item for both Minox collectors and collectors of espionage equipment, the Mikrodot Gerat (Microdot Apparatus) was a custom-built item. In the early 1950s Don Thayer Snr. received an inquiry from the intelligence community to determine if Minox might be interested in manufacturing some form of microdot-making machine. Devices for doing this usually consisted of a two-stage optical train in which a 35mm copy was further reduced to the dot. The Minox Mikrodot Gerat was a reversed enlarging system, using Minox-size originals as the starting image. A side column microscope enabled the operator to make the critical focusing adjustments, and some form of

Model M1 portable briefcase-type microfiche reader, introduced in 1988.

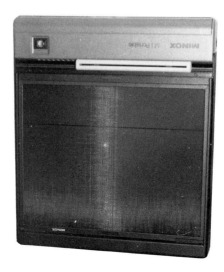

Lippman or Goldberg ultra-high resolution emulsion was employed. The device often had to be set up on a concrete table to isolate it from vibration and used in the middle of the night, away from heavy traffic, to avoid vibration which would degrade the image of the dot. Factory records indicate that between 70 and 80 units were made up, some units going to agencies outside the U.S.

Minox Mikrodot Gerat, early configuration. (Courtesy Cornwall Auctions)

Minox Mikrodot Gerat, later configuration.

APPENDIX 1

Minox Serial Numbers

Serial numbering is often used to determine the quantity of a given model produced and the time period in which production occurred. Serial numbers for the majority of 9.5mm and 35mm models are given below, taken from factory records. The reader is cautioned that subtracting the initial serial number from the final one of a given model is a good indication of the maximum number of that model **planned** for production. However, in some cases production could have been less due to interruptions and materials shortages. Furthermore, in keeping with many firms' policies of proprietary information, only the starting serial numbers are given for cameras currently in production. The author is indebted to Werner Umstatter for having first disclosed serial numbering data in his book *Photographie 1839-1979* published by the Verkehrs-Museum, Berlin, Germany in 1980.

Riga Minox

The earliest known, fully documented Riga body is No.01104. The latest known, fully documented Riga body is No.18460. Lack of any known and numbered Riga bodies below No.01000 (with exceptions noted below) tends to indicate that **production** serial numbering began at No.01000. By the time body numbers reached No.18500, the 3-element Riga lens design disappears, and at approximately No.20000, the 5-element postwar lens design of the Model II begins to appear. A single Riga body, No.00025, has been reported but it is not fully documented. Another Riga body, serial No.00113, appears in early instruction books and advertising literature of the Riga period. The Riga production period is taken as 1937 thru 1944 and includes both Latvian and Russian engraved outer shells. VEF records in the CVVA (Latvian Central State Archives) indicate that the total number of Russian engraved variants for both periods of Russian occupation is less than 2000, well under the 5000 figure planned by the Russians under the "State Plan for 1941" (see *American Council of Learned Societies Reprint: Russian Series No.30*, Universal Press, Baltimore, 1951, page 111). The Riga is also referred to as Model I by some collectors.

Minox II

The earliest, fully documented Model II, with original 5-element lens is No.20379. The access "hatch" feature appears spasmodically in the serial

numbering range from No.25300 to No.31500. Some Model II's in this range
have been factory converted to either Models III or III-s.

Minox III

1951	31275-39414
1952	39415-49895
1953	49896-58499

Minox III-s

The first factory original III-s appears around serial number 60000 (approximately March 1954)

1954	58500-70292	1959	140767-140853
1955	70293-86588	1960	140854-141483
1956	86589-111207	1961	141484-141843
1957	111208-136741	1962	141844-145774
1958	136742-140766	1963-69	145775-147494

Note: Models II, III and III-s were also known collectively as Model A in Europe
after Model B was introduced in 1958.

Model B

1958	600001-622397	1965	837957-867929
1959	622398-661617	1966	867930-901404
1960	661618-701762	1967	901495-936194
1961	701763-735254	1968	936195-972874
1962	735255-766622	1969	972875-979561
1963	766623-805699	1970-72	979562-984328
1964	805700-837956		

Model C

1969	2300101-2322178	1973	2424404-2445732
1970	2322179-2364449	1974	2445733-2458061
1971	2364450-2403703	1975	2458062-2469964
1972	2403704-2424403		

Model BL
1972-73 1200001-1217880

Model 110S
1976-79 4500001-4539618

Model LX (currently in production)
Began in 1978 with 2500001

Model EC (currently in production)
Began in 1981 with 2700001

Notes on serial numbering of gold 9.5mm Minoxes
1. Two gold Model III-s cameras are presently known to have bodies Nos.108521 and 127014
2. Two gold Model B cameras are presently known to have bodies Nos.966237 and 983762
3. Because the bodies were serial numbered in advance of the gold shells, and the random choice for making up a gold III-s or B, such models found today may or may not be in their original gold shells due to possible original body replacement during drastic repairs. With the exception of the run of gold LX cameras (serial numbered from 001 to 999) currently produced, factory records for original gold-cased body serial numbers are not extant today.

Enlargers
Postwar Enlarger (squat cylinder/parallelogram opening)
April 1950-February 1951 100-781

Model II/III Enlargers (conical body)
First date of production June 1951

Beginning serial number 1000
Number made up to present Approximately 1500

35mm Cameras
35 EL

| 1975 | 3501001-3528450 |
| 1976 | 3528451-3608656 |

Note: A current 35mm model, the GT-E, bears serial numbering in the 5000000 range. As already noted, serial numbering information on most currently-produced models is held to be proprietary insofar as any given run for any given year is concerned.

APPENDIX 2

Patents Relating to Minox

All too often, most people view patents as mysterious legal documents. Engineers and technicians, especially, are notorious in their neglect of patents as the largest source of technical information in the world. In many cases, the patent literature is the only place where detailed functional information is available. The patents below have pre-WW II application dates and include not only the patent for the camera itself, but patents for cassette, film advance, lens-focusing, and viewfinder mechanisms. Specific mechanisms are identified in the case of the United States patents. Copies of the patents or abstracts of the patents can be found in the U.S. Patent Office Scientific Library, British Patent Office Library, and patent libraries of major countries having patent systems. Photocopies are obtainable by mail for very nominal fees. It is very important that the patent number be given when ordering.

U.S. Patents

2169548	camera
2161941	film feed/transport
2147567	lens mechanism
2218966	cassette
2278505	viewfinder

Argentina	48091
Australia	106748, 106884, 106885
Austria	155506, 155508, 156018
Belgium	425145, 425146, 425147, 425148
Canada	379803, 379939
Danzig	2580, 2582, 2583
Denmark	56361, 56524
Estonia	2627, 2628, 2630
Egypt	237
Finland	200056
France	830509, 830556, 830650, 848209
Germany	DRGM 1454419, 1454423, 1454429; DRP 701587
Great Britain	494544, 495149, 506749

Hungary	120373, 120864
India	25685
Italy	357904, 357225
Norway	61091, 61092
Switzerland	199802, 199803, 199804
Sweden	92523, 92524, 92525
Union of South Africa	1137, 1138

Additional Patents issued to Walter Zapp (post 1950)

U.S. Patent numbers only are given below. The major subject (not the actual title) of the patent is mentioned and in some cases the invention is non-photographic in nature.

3153375	camera
3186376	exposure counter
3409343	magnifying viewer
3986627	bottle closure
3990598	bottle closure
4009794	bottle closure
4077295	turning peg for musical instrument
4078687	bottle closure
4081068	typewriter keyboard
4198114	magnifier worn on head
4201489	typewriter keyboard

Additional Patents held by Minox GmbH (post 1950)

3655949	data processor
3750550	still camera with flash
4057814	subminiature camera construction
4117513	telescoping housing camera
4170408	collapsible microfilm viewer
4185901	microfilm reader
4365884	camera with retractable objective (35mm feature)
4423933	microfiche reader
4465349	automatic microfilm card reader

Bibliography

The Minox has been the subject of over 300 articles and books in at least a dozen languages. Space limitations and transliteration prevent a large number of these from being cited here. The list below comprises the more detailed and unusual works written in English, German and Japanese. This material can usually be found in larger libraries and photocopies of articles can often be obtained thru the inter-library loan facilities in most countries.

Works in English – Books
Cooper, Joseph D. *The Minox Manual* various editions, 1958 thru 1967. *Minox Pocket Companion* Universal Photo Books, 1962. *Ultraminiature Photography* various editions, 1958 – Joseph Cooper's works were the first definitive Minox books in the English language and are highly desired by Minox users and collectors today.
Emanuel, Walter D. *Minox Guide* various editions, 1958-1975
Kasemeier, Rolf *Small Minox – Big Pictures* various editions, 1959-1970
Tydings, Kenneth S. *New Minox Guide* 1963

Works in English – Articles
Hendre, Enn Dr. Ing *Fifty Years of the Sub-Miniature Minox* History of Photography, Vol. 13, No. 1, Jan-Mar. 1989
Buchler, Walter *A New Miniature Camera* Popular Photography, Dec. 1938, p. 56
Author unknown *Unique Camera Weighing Only 4½ Ounces* Miniature Camera World, Sept. 1939, p. 778
Author unknown *The Minox Precision Miniature* The Miniature Camera Magazine (London), Oct. 1939, pp. 1031+
Author unknown *Comsumers Report, Subminiature from Abroad* Camera Magazine (Baltimore, MD) Nov. 1951, pp 99+
Author unknown *Is The Minox Practical?* Modern Photography, Feb. 1955, pp. 58+
Moreton, David O. *The Minox Camera* Law and Order, Apr. 1956, pp. 15+
Sheffield, Dennis *How Small Can a Camera Get?* British Journal of Photography, 24 Apr. 1959, pp. 234+

Lerici, Carlo M. *Periscope on the Etruscan Past* National Geographic, Sept. 1959, pp. 337+

Schneider, Jason *The Camera Collector* Modern Photography, Sept. & Oct. 1972. An informal account of the history of the Minox based on interviews with two former VEF employees

Hughes, Tim *Minox 110S* British Journal of Photography, 25 Nov. 1977, pp. 1002+

Works in German — Books

Kasemeier, Rolf *Kleine Minox — Grosse Bilder* 1959-1970

Kasemeier, Rolf *Minox 35-Spritzentechnik im Taschen Format* 1986. This is the definitive work on the use of the Minox 35, including fully detailed descriptions of the technical features and applications of all 35mm Minox cameras manufactured up to 1986.

Strache, Wolf *Foto Grafieren mit Minox* 1970

Stuper, Dr. Josef *Kleinstbild-Technik* several editions, 1950-1957

Works in German — Articles

Bickel, Edmund *Die Lettlandische Minox* Photographie fur Alle,20 Jahrgang 18 (1940)

Hendre, Enn Dr. Ing *Tallinn-Geburtsort der ersten kleinstbild Kamera Minox* Feingeratetechnik, Berlin, 5, 1985. This article deals with the Estonian prototype of the Riga Minox and is important from an historical perspective

Author unknown *Ein interessanter Einsatz der Minox* Photo-Technik und Wirtschaft, 1951, No.3

Liesenfeld, Dr. Heinz J. *Fundusphotographie mit Hilfe ... und der Minox kamera* Klinische Monatsblatter fur Augenheil Kunde, Bande 130, Seite 854-859. A very unusual article dealing with Minox and photography of the human eye

Stuper, Josef *Die Kleinstbildkamera Minox* Foto-Spiefel, No. 5/6, Feb/Mar. 1948

Author unknown *Die Kleinste Prazisions Kamera d. Welt* Camera (Luzern) 18 Jahrgang 189 (1940)

Works in Japanese — Books

Japan Minox Club *Minox* The definitive work on Minox in Japanese. Written by members of the world famous Minox Club of Japan, this well-illustrated 188 page book consists of five parts. Part 1. How to use Minox. Part 2. History of Minox. Part 3. Accessories. Part 4. Advanced Techniques. part 5. References and Miscellany. 1987. Limited edition of 1000 copies. Excellent 4-page bibliography.

Miyabe, Hajimu and Kanai, Hiroshi *Minnokusu to mini Kamera* 1st edition 1978, 2nd edition 1980

Miyabe, Hajimu *Mini kamera no sekai* 1983